BATH
MURDERS AND
MISDEMEANOURS

T0277434

MICK DAVIS

AMBERLEY

First published 2022

Amberley Publishing
The Hill, Stroud
Gloucestershire, GL5 4EP

www.amberley-books.com

British Library Cataloguing in Publication Data.
A catalogue record for this book is available from the British Library.

ISBN 978 1 3981 1134 9 (paperback)
ISBN 978 1 3981 1135 6 (ebook)

Typesetting by SJmagic DESIGN SERVICES, India.
Printed in Great Britain.

CONTENTS

FOREWORD

When I co-created *The Regency Detective* series of novels, with fellow author Terence James, one of the main intentions was to show the darker side of Jane Austen's Bath; a side deliberately, and understandably, left out of guidebooks to the city at that time, and a place where Austen herself never dared to venture either in print or person. Jack Swann – the perennial lawman of the title – stalked the streets and alleyways of what was hopefully an historically accurate picture of early nineteenth-century Bath, fighting crime and inhabiting a world full of pickpockets, thieves, prostitutes, and the rest of the criminal underclasses, but both hero and villains were still mere creations of our imaginations.

The rogue's gallery of miscreants on show within the pages of Mick Davis's fascinating book are, on the other hand, only too real. They all existed at some point in the city's murky and shadowy past, and during their allotted time on earth committed numerous misdemeanours, foul deeds and, in many cases, murder. Indeed, several of these characters – the highwayman, femme fatale, gang leader, and resurrectionists, to mention just a few – would not have been out of place within their fictional counterpart, rubbing shoulders with and pitting their wits against the aforementioned Swann.

Although names such as Charlotte Marchant, Reginald Hinks, Joseph Madden, William Clarke and the others that grace this volume may not sound as familiar as Florence Maybrick, Dr Crippen, or Burke and Hare, the crimes presented here, committed in our city, were just as gruesome, cruel or potentially infamous as those undertaken by their more notorious equivalents, many of whom have been elevated to an almost canonised state by a seemingly insatiable readership of true crime. Of the better-known cases, Mick's meticulous investigations have brought to light previously overlooked details or discovered facts hitherto unconsidered, forming an invaluable contribution to the history of the city.

There does seem to be an endless fascination in reading about the more depraved aspects of human nature from the safety of one's armchair, perhaps vicariously experiencing the situations, actions and consequences that occur through criminal activities with predictable regularity but which few of us meet in our ordinary lives. If that is your reason for reading this book you will not be disappointed, with its wide-ranging spectrum of botched suicides, greed, depravity, manipulation, inept murder attempts and at times, perhaps, pure evil.

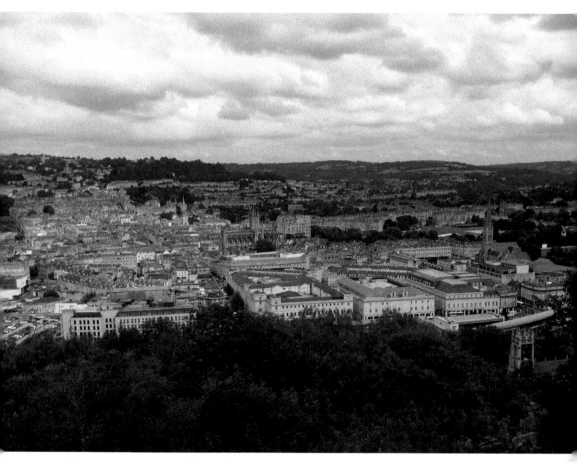

The Georgian city of Bath from Beechen Cliff.

This was originally a book that we were to work on together, but other commitments on my part meant Mick had to traverse the ominous path into Bath's sinister past alone. I am, however, glad to contribute this foreword and to have the opportunity as a reader, like yourself, to take that journey into the dark heart of the city in which I was born.

David Lassman, January 2022

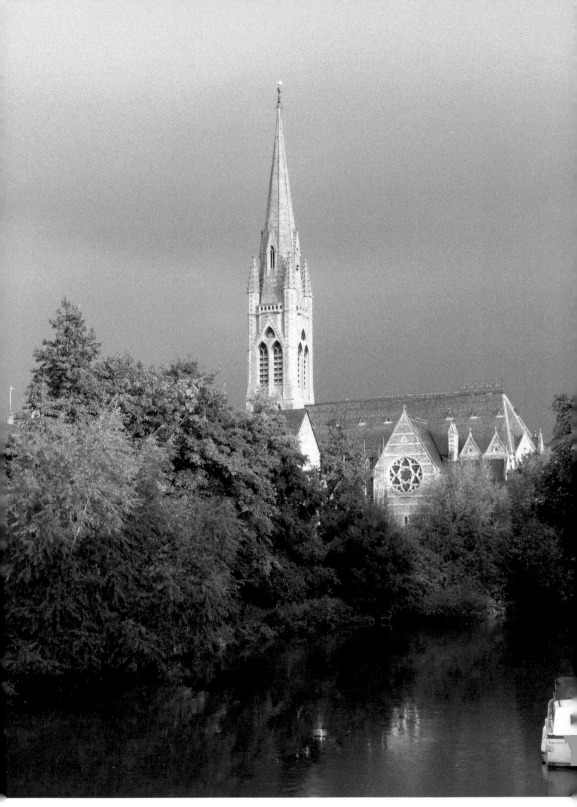

St John's Church.

ACKNOWLEDGEMENTS

Many thanks are due to David Lassman who was to have joined me on this arduous task but was drawn away by more pressing duties. I would also like to thank Anne Buchanan of the Bath Record Office for her very helpful replies to my questions, my wife Lorraine for all her help and forbearance, and the ever-reliable D2 bus for transporting me many times from Frome to the glorious city of Bath. The various maps are reproduced from the Ordnance Survey's collection and aimed at being as close to the time in question as possible. Every attempt has been made to trace the copyright holder of any unreferenced material and if I have inadvertently used some copyrighted material without acknowledgement I apologise and will make the necessary correction at the first opportunity. The choice and research for each item was entirely my own.

Bath from Beechen Cliff.

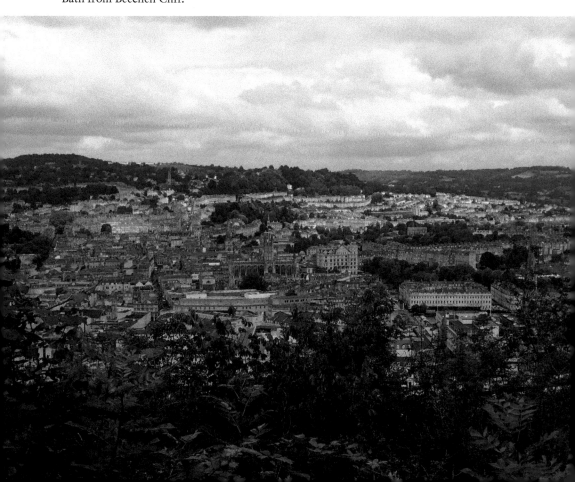

ABOUT THE AUTHOR

Historian and author Mick Davis was brought up in Plymouth before finding his way to London where he worked for one of the city's top criminal defence lawyers covering everything from shoplifting to serial killers before making a permanent home in Frome, Somerset, in the early 1990s with his wife Lorraine. He now spends his time researching and writing full time. As well as criminology his other interests include prehistory, archaeology and electric blues.

Mick is editor of the Frome Society Yearbook and a volunteer at Frome Museum. His other publications include: *Of Mounds & Men*, a guide to the prehistoric burial mounds of the Frome area; *A Surfeit of Magnificence*: *Trials & Tribulations of Sir Thomas Champneys of Orchardleigh*; *The Historic Inns of Frome*, Frome pubs past and present with Valerie Pitt.

In collaboration with David Lassman: *The Awful Killing of Sarah Watts*, unsolved Frome murder of 1851; *Foul Deeds and Suspicious Deaths in and around Frome*; and local crime stories *Frome Murders and Misdemeanours*, in preparation with Amberley Publishing.

JOHN POULTER, HIGHWAYMAN (1751)

The eighteenth century was undoubtedly the golden age for the highwayman. Romantic stories of the gentleman thief on horseback holding up stagecoaches, charming the ladies and robbing their companions were a popular diversion in Victorian times, when that period was looked back upon with nostalgia. It was the age of the coaching inn, the mail coach and an increase in general commerce and prosperity, which led to a need for faster and more efficient travel. Gentlemen travelling on business would need to take cash with them from town to town and where there is money there is very often someone trying to steal it.

The idea of the highwayman as a 'gentleman of the road' had some basis in truth as the career took off after the 1650s when the Civil War left many well-born Royalists penniless with little apart from some skills learned from soldiering, which they applied to their new profession. Despite these legendary exceptions, most were thuggish opportunists and most were caught and hanged before the age of thirty-five. Greater policing of highways, large rewards for information leading to their capture, armed guards on coaches and increased security meant that their reign was largely over by the 1830s.

Outstanding among this gang of blackguards was John Poulter, a native of Newmarket born in 1715 who had a good education and was employed as a stablehand to the Duke of Somerset before being involved in transporting horses to France and travelling to America and the West Indies. Despite advantages over many of his fellows and abilities that would have enabled him to pursue any

Stand and deliver!

number of legitimate careers, it seems that the lure and excitement of easy money was too great to resist. In 1749 he teamed up with John Brown and the pair assembled a gang of thieves and robbers based in Bath, which broke into houses across the country, moving from place to place when their activities drew too much attention, before returning to their adopted town to rest and divide up the spoils. The gang had, as one of its main hang-outs, the Packhorse Inn at Bath run by one John Roberts.

When the law started to close in on him, Poulter made his way to Dublin where he took a pub at Aston's Quay and settled down to a quiet life. Sadly he was recognised by some of his former associates who began to hang around the pub, turning it into a haunt of villainy, which gave rise to constant police raids destroying his custom. After a few more failed attempts to make an honest living in Ireland, he returned to Bath in 1751 and took up once more with his old criminal contacts, who had moved on from burglary to highway robbery. The gang travelled the country again, turning their hands to horse stealing, which they organised by taking them from the West Country and selling them up north before stealing more from that district and returning to the Bath area to sell there. Gambling, fraud and picking pockets were regular activities when the highway trade was lax.

Returning once more to Bath, they let it be known that they were smugglers to account for their free-spending ways, expensive clothes and frequent absences from the city. Smugglers were thought of as Robin Hood figures as the taxes on imports like tea, tobacco and spirits were very high and smuggled goods brought the price down, making them more generally available. To maintain the illusion,

The Packhorse Inn, Midford, in the 1960s.

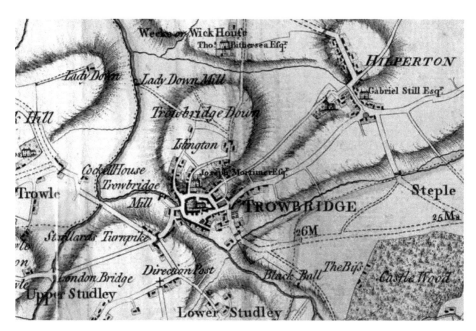

Part of the road to Trowbridge.

they went to the extent of buying tea at seven shillings a pound and reselling it at four shillings and sixpence so that people would think it had been smuggled. One of their tricks took place at a pub in Lincolnshire, where they bet a man who had no money one guinea that he could not borrow twenty guineas in half an hour. When he succeeded they involved him in a rigged card game and, of course, he lost the lot. The firm then beat a hasty retreat.

Obviously, the good times could not continue forever. On the road to Trowbridge, Poulter was accompanied by a young lad named Burk who was learning the trade. They came across a post-chaise within which was a Dr Hancock, his daughter and young child. The job went wrong from the start. Poulter put his hand through a window, cutting his wrist and accidentally discharged his pistol. Burk assumed that the passengers were firing and discharged his own pistol into the carriage, but fortunately no one was hurt. In his account of the affair, Poulter denied rumours that he took over thirty pounds from the doctor and claimed that his reward was less than two guineas and a quantity of clothing. A short time after the robbery Poulter was tracked down, arrested and committed to Ilchester jail. After pleading guilty at the Wells Assizes, he was sentenced to death.

He confessed his crimes, hoping for a reprieve, and wrote an account of his activities, naming over thirty of his assistants and co-conspirators. This account was published, enabling many of those named to escape so that only around a dozen were eventually arrested. Poulter's confessions received some sympathy from various persons in authority who petitioned for him to be pardoned.

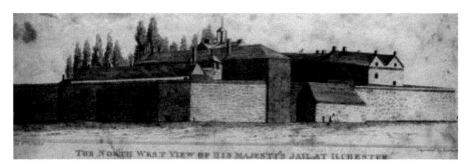

The Old Jail at Ilchester.

THE
DISCOVERIES
OF

John Poulter, alias Baxter;

Who was apprehended for robbing Dr. HAN-
cock, of *Salisbury*, on *Clarken- Down*, near *Bath*; an i
thereupon difcovered a moft numerous Gang of Villains,
many of which have been already taken.

BEING

A full Account of all the *Robberies* he has committed, and
the *furprifing Tricks* and *Frauds* he has practifed for the
Space of five Years laft paft, in different Parts of *England*.

Written wholly by H I M S E L F.

To which he has added for the Service of the Publick, to
make all the Amends in his Power for his paft Offences,
DIRECTIONS to fecure Houfes from being broke open. How
to prevent Horfes being ftolen out of Grounds, Commons, or
elfewhere. Ufeful Cautions to Tradefmen and others who
travel the Roads, to prevent their being robbed. And to pre-
vent any unwary Perfons from being impofed upon and de-
frauded, an exact Account of the Manner in which Gamb-
lers and other Sharpers impofe upon People at Fairs, &c.
The Arts the Horfe-Dealers make Ufe of to draw in People
to buy or exchange their Horfes ; and the various other Cheats
practifed at Fairs, as giving Notes for Goods, pricking at the
Belt, exchanging Saddles and Great Coats at Inns, &c. In
what Manner Shopkeepers are cheated by Shoplifters : With
every other Trick and Species of Villainy made Ufe of by
Rogues and Sharpers, laid open in fo plain a Manner, and
their Behaviour and Language fo fully defcribed, that every
one who reads the Book, may certainly know them at any
Time, and fo be upon their Guard againft being cheated by
them.

The FOURTEENTH EDITION.

Printed for R. GOADBY in *Sherborn:* ;
And fold by W. OWEN at Temple-Bar; and J. TOWERS at,
No. 111, in Fore-ftreet, *London*, 1769.

Poulter's *Book of
Confessions.*

A typical court scene.

The jailer at Ilchester, however, was not among them and gave his prisoner an extremely hard time, not allowing him a bed or blanket despite the freezing weather. His last victim, Dr Hancock, visited him pretending to have much sympathy with his situation but in fact he was trying to get his execution brought forward, despite having had most of his property returned.

His execution had been set for 1 March but he was granted a reprieve of six weeks so that he could give evidence against his former associates. Seizing an opportunity with a fellow prisoner, he loosened one of his window bars and escaped. Still wearing the prison leg irons and making for Wales, he got as far as Glastonbury before spending six hours in a wood getting them removed and then trudged on to Wookey. Suffering from exhaustion with sores on his legs caused by the irons, and desperate for somewhere to rest and recover, he went to an alehouse at Oakey where he was recognised and recaptured. Presumably his confessions had alienated his carefully compiled network of underworld contacts and there was no one to whom he could go to for help.

Once back in Ilchester the jailer petitioned for his immediate execution and, according to newspaper reports, none of his associates had been charged at the time of his execution, which removed the main reason for keeping him alive. He was hanged on Monday 4 March 1754 at the age of thirty-nine.

The fate of two of his named associates are known. John Roberts, who kept the Packhorse Inn, which the gang used as one of their headquarters, died while being transported from Shepton Mallet to Taunton Castle for his trial. It was thought that he poisoned himself.

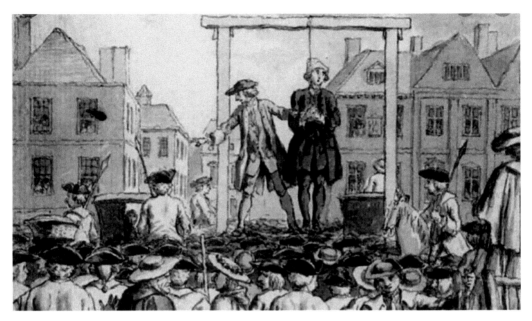

Many highwaymen ended their lives on the scaffold.

Eleanor Tobin, aka Conner, was sentenced to death in 1748 for picking pockets but the sentence was reduced to fourteen years' transportation. However, before the ship left harbour she was rescued by a group of her associates and escaped. Once Poulter let it be known that she was still alive and active, she was tracked down and sentenced to death once more at the Old Bailey in April 1754 for 'returning from Transportation before her time had expired'. She was found to be pregnant, which caused her execution to be postponed until 9 December when her luck finally ran out.

2

THE RESURRECTIONISTS: CLARKE AND MADDEN (1826)

Joseph Madden is first mentioned on 9 July 1821 when, at the age of twenty-one, he was in Shepton jail on a warrant for failure to provide for a 'bastard' child. He appeared at the Bridgewater Assizes and was 'confined until the next sessions', presumably because he was unable to show that he could support the child. While there, on 13 August 1821, he was allowed out to marry twenty-one-year-old Harriet Moody at Shepton Mallet where Madden

Early Ordnance Survey map of Walcot Cemetery.

was described as 'of St James in the City of Bath (but late in Bridewell)'. It is not known whether the child was Harriet's but he was returned to prison until 15 October 1821 when he was discharged, presumably after settling his affairs to the satisfaction of the court.

On 18 February 1826 he was committed to Ilchester jail, along with William Clarke and William Broderip, to stand trial at Taunton on 25 March for 'removing dead bodies from Walcot churchyard'. William Clarke had been found with four bodies in his house and confessed that he had assisted in the procuring of 2,000 bodies for anatomical purposes, having been introduced to the trade when he was six years old. In his confession he claimed that when subjects were scarce he had been paid as high as ten guineas a piece and had been tried twenty-eight times for this offence, but from various causes had escaped from all but two of the indictments on which he was convicted and punished. Clarke had, with an assistant, hired a small house with a view of Walcot burial ground, so that when the burial took place he was fully aware of the time, place and subject. They had set about their task so industriously that, between October and February, they had plundered the burial ground of at least forty-five bodies which were packed up in hampers and sent off to London by coach. When his house was searched, three bodies were found packed in this way ready for conveyance by coach and a fourth was in a closet covered with straw. In the cellar there was an immense quantity of human bones, which he was preparing to assemble into complete skeletons. Clarke did not deny the charge but complained, rather foolishly, that the medical gentleman who had promised to come forward in his support had not done so. He was found guilty and before judgement pleaded for mercy maintaining that *subjects*, as he referred to them, must be obtained for the purposes of medical science and that the obtaining and acting upon them was very advantageous to the living, drawing a connection between his profession and loyalty to the King. Clarke claimed that he had procured four subjects for Sir Astley Cooper so that he might practice on them before operating on George IV himself.

Mr Justice Burrough was less than impressed and expressed his disgust at the conduct of the prisoner, saying that he considered the case to be very serious, and sentenced Clarke to twelve months in the 'common jail' plus a fine of £100. Madden and Broderip were acquitted for lack of evidence and Clarke was discharged on 6 May 1827, having served his time and the fine being paid.

The sentence may seem light in view of the huge number of *subjects* that he claimed to have excavated and the insolence of his boasts, but legally the dead did not belong to anyone and it was something of a grey area. They had to be careful however; if they had taken anything else from a grave, even a shroud, that would have been theft and taken very seriously. Although the public were horrified, many professionals saw the need for bodies to facilitate research.

William Broderip was transported for life at the 1827 Summer Assizes after being found guilty of theft for the second time. He set sail on the *Bengal Merchant* for Van Diemen's Land on 13 March 1828 and nothing further is known.

Site of Walcot Burial Ground.

Madden's wife Harriet gave birth to a daughter named Matilda on 11 September 1826, at which time they were living at Cornwell Buildings in the Walcot area of Bath. Madden is not recorded as having been before the court again until he was arrested and committed to Ilchester jail on 14 July 1828. It seems that he had forsaken the pleasures of the graveyard and appeared on this occasion on the very unlikely charge of having stolen '50 canaries, two stone pitchers etc, the property of William Bridle of Sydney Gardens'. This time he was convicted and sentenced to eight months in Wilton jail, two weeks of it in solitary confinement. The jail description book describes him as a plasterer aged twenty-six, 5 feet 7 inches tall, of sallow complexion, with hazel eyes, dark brown hair, three cuts to his forehead and a mole on his left arm.

His old comrade Clarke had not fared so well: there are few details but it seems that he was arrested for burglary and sentenced to be transported for life, leaving for Van Diemen's Land on the ship *Layton* on 13 June 1827 and arriving the following October. He was described as a weaver, around twenty-four years old, 5 feet 7 inches tall, of ruddy complexion, dark brown hair and grey eyes. He received his ticket of leave in 1840 and lived in the Penrith District of New South Wales until he died in 1849.

Cornwell Buildings, Walcot.

Meanwhile, on 10 February 1830 Harriet Madden gave birth to another daughter, Sarah, while they were still living at Cornwell Buildings. Both daughters were baptised on 12 January 1831. A third daughter was baptised on 3 August 1831, by which time they had moved to 4 Camden Street, but she died at the age of eighteen months.

At the Lent Assizes in 1830, Madden was accused of having returned to his old trade – not plastering, but stealing bodies. The charge stated that he was with John Lawrence, a thirty-seven-year-old labourer, and had unlawfully in his possession three dead bodies for the purpose of dissection. The facts were that, in March of that year, three men took an oil cask by cart to the office of Mr Cruttwell in Abbey Green with the intention of sending it to The Borough in London. It seems that they had been informed upon, and when the cask was forced open it was found to contain the bodies of two men and a woman. One man managed to escape but Madden and Lawrence were caught and examined before the mayor and magistrates at the Guildhall before being committed for

trial. Madden was described as an old offender and most notorious character who had been connected with the infamous Clarke. Once again, the case against him was dismissed for lack of evidence but Lawrence received twelve months in Wilton jail.

Inevitably, Madden's luck ran out. On 1 July 1833, at the Somerset Quarter Sessions, he was convicted of stealing a gown and a quantity of linen from a Mr Norrison's premises in Sydney Gardens along with a man named Henry Burton. They were sentenced to transportation for seven years and removed to the *York* prison hulk at Gosport on 30 July 1833. The pair set sail on the *Hive* on 15 January 1834 and arrived in New South Wales on 11 June 1834.

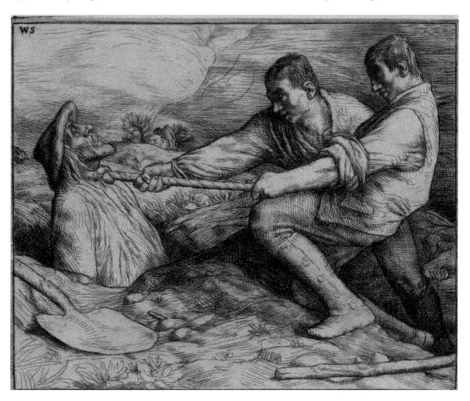

The Resurrectionists by William Strang. (CC by NC)

3

THE MURDER OF MARIA BAGNALL
(1828)

According to his evidence given at the coroner's inquest, Richard Gillam, a butler in the employ of elderly widow Mrs Elizabeth Coxe then residing at 16 Marlborough Buildings near the Royal Crescent, was preparing for bed at 11 p.m. when he met Coxe's lady's maid, Maria Bagnall, on the stairs and after a mutual 'good night' they went to their separate quarters. Soon after 2 a.m. Gillam was awakened by a sound like somebody picking a lock and took the stairs down from the attic to investigate. He found that the door on the stairs had been jammed shut and he could not open it. He returned to his room and loaded three pistols, one with a blank cartridge and two with balls. He fired one of these at the door in the hope of opening it but it had no effect. In what seems like something of a panic he discharged the other pistols out of the window and began shouting 'Murder!', which alerted the watchman nearest the house who used his rattle to bring others to the property.

The butler shouted from the window that something was wrong and that he was unable to get downstairs, entreating them to try to enter from the back, which they did, finding the back door open. The door on the stairs had been secured by a gimlet and, once released, Gillam and the watchman descended to the kitchen where they discovered that a murder had been committed. Maria Bagnall was lying to the left of the fireplace with her face on the floor and a bludgeon of wych elm by her side, her throat cut so deeply as to have divided the windpipe and arteries, her left hand was bruised and swollen, the third finger on her right hand was almost severed and there were several other wounds.

The surgeon, Mr King of Brock Street, was sent for and concluded that she had been dead for two or three hours. The party looked around the house; everything was found in disarray. Every drawer and closet had been opened and examined, some of the servants' clothes were packed up, and the silver tea urn had been removed from the closet under the stairs where the plate was usually kept and was found on a lower story. On a table were found four bottles removed from a cellaret, some of the contents of which appeared to have been drunk by the intruders. At the entrance to the cellar they found a basket with an undressed leg of mutton, a shoulder of mutton and two loaves. It did not appear that any article had been taken from the house and everything gave the appearance of a gang of robbers caught in the act by Bagnall who they killed before fleeing.

A nightwatchman with rattle, cudgel and rather battered lamp.

After a careful and patient investigation, which continued for more than nine hours, and the examination of eight witnesses the jury returned a verdict of 'wilful murder by some person or persons unknown'.

The victim, Maria Bagnall, was around forty-three years old and had been with Mrs Coxe, a widow of eighty years, the late wife of Charles Coxe of Lypiatt, for the past two years. Richard Gillam, the butler, was born in 1803 at Taplow, Buckinghamshire, of a most respectable family, and had been in the job for fifteen months. He had married the cook, whose name has not come down to us, around two years before.

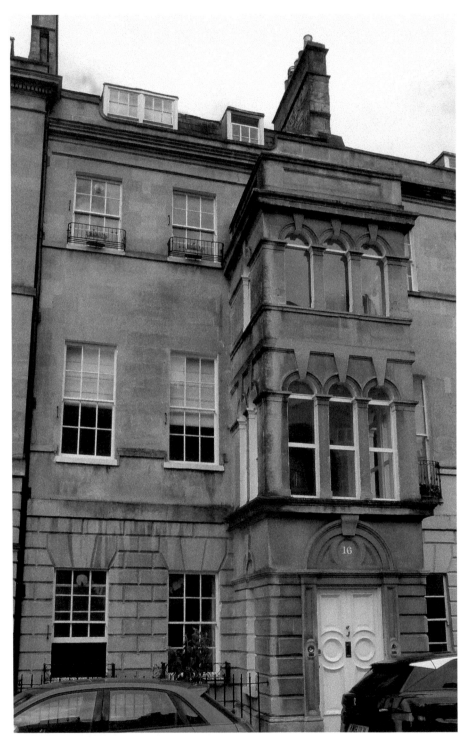

16 Marlborough Buildings.

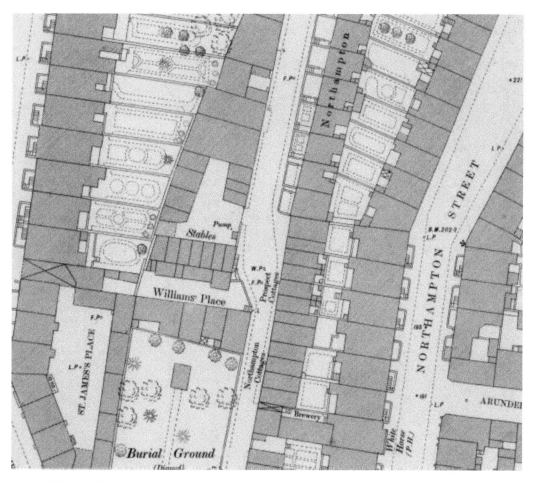

Williams Place, Bath.

Despite what appeared to be a simple case of burglary gone wrong, the investigators were suspicious. Gillam underwent repeated examination but revealed nothing that would cast doubt on his story. However, he was unable to account for some spots of blood on his clothes and his story differed in some respects to that of the watchman. Further investigations revealed that he had sent several packages from Marlborough Buildings to a room he hired in William's Place at the back of Northampton Street. The packages contained china bowls, teacups and saucers, plates, dishes, knives, forks, seventeen bottles of wine and many other goods, all of which were the property of Mrs Coxe. When confronted with the items he declared that 'it was all over with him' and nearly fainted. He accepted the thefts but initially denied the murder until eventually confessing and was conveyed to Shepton Mallet prison. Despite his most careful planning, bloodstained clothing had been found in his room, which must have been pretty conclusive. A very silly mistake – perhaps he thought that blows to her head

would have killed her without much blood or underestimated the amount that slitting her throat would produce.

The prison description book for 10 April 1828 at Ilchester describes him as aged twenty-four of slender build, pale complexion, long face, brown hair and able to both read and write.

In his confession he said that after going to bed with his wife he said that he must go downstairs again as his bowels were disordered. He then collected the stick, which he had cut some months before, and struck Maria repeatedly until she was on the floor, at which point he knelt on her body and, taking his pocketknife, cut her throat. He then arranged all the items as they were found to indicate a burglary, pouring some of the wine down the sink to add colour to the story. It was all very cleverly done and almost worked. As to motive, he claimed that Bagnall had suspected his thefts and had threatened to tell Mrs Coxe. The pair detested each other and he had been planning the crime for some time. Despite his confessions, at his trial he pleaded not guilty and, 'presented the most respectable appearance, genteelly dressed with a dark brown coat, light waistcoat and white cotton stockings'. The evidence was overwhelming and he was convicted at Taunton in front of Mr Justice Littledale, the jury taking only ten minutes to reach their verdict.

His last few moments.

The prisoner's countenance during the trial underwent very little variation; but on receiving sentence he held down his head, a death like paleness came upon him and he appeared to be labouring under the workings of an overburdened conscience and a sense of his dreadful situation. The court was exceedingly crowded throughout the trial and the attendance of fashionably dressed females [was] very numerous.

Gillam was hanged at Ilchester jail on 4 June where

... the attendance was very small, not above 100 people. He ascended the scaffold without faltering and after praying fervently the drop fell and after a few convulsive struggles he was still. His body was delivered the same day to a Mr Norman of Bath for dissection.

4

MURDER AND SUICIDE: JAMES BEERE (1829)

On Monday 23 November 1829, at around 5.30 a.m., Catherine Chappell heard a sound that she thought was 'like a gurgling in someone's throat' followed by the door of the neighbouring room at her lodgings at 1 Williams Place, near the back of St James Street, opening and closing and the sound of footsteps hurrying away. Concerned that her neighbours might be in trouble she went to the door of the adjoining room, occupied by James Beere, his wife Mary and their nine-month-old son, Charles, and called her name several times but received no reply. With her husband in attendance holding a candle, she made her way to the bedroom. The sight that met her eyes was described by one paper as 'of a more horrible nature than it has ever been our unpleasant task to record'.

> The mother was lying on her back with one hand across her breast and her throat cut from one angle of the jaw to the other dividing some of the principal arteries and windpipe, the little innocent about four months old, which appears to have been lately drawn from the breast for the murderous purpose, was lying on its side with its head severed excepting by a bit of a skin at the back part of the neck. The bodies were weltering in blood, a pool of which ran under the bed and extended across the room. It was evidently the result of a cool and deliberate intent for it appeared that the date was committed while the sufferers were asleep, there having been no noise heard by any of the lodgers or neighbours, excepting that described by Mrs Chappell which was after the deed had been perpetrated and the murderer had escaped.

Mr White, a local surgeon, was summoned immediately along with the police. In a box on a table near the bed and lying open was a razor, clotted with blood, its box lying downstairs next to a hatchet as though it was ready for use if the razor did not accomplish the task.

James Beere was a journeyman baker and native of Widcombe, described by the lodgers as a very steady man, fond of his wife and his home, who idolised his child. He was industrious at work, being employed as a foreman baker by a Mr Davies of St James Street, James Square. The couple had been married for around a year.

Shortly after daylight a baker's jacket with blood on it was seen lying on the bank of the river near Bedford Street, Walcot, and a boat dispatched. Pretty

Right: A cut-throat razor.

Below: Bedford Street leading down to the river.

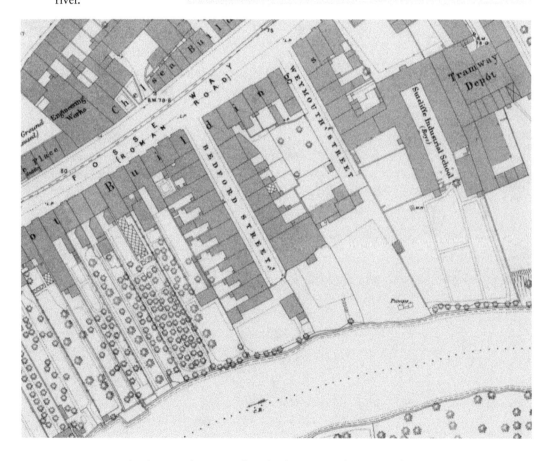

soon Beere's body was discovered and taken to Walcott warehouse to await the coroner's inquest. A colleague of James, Mr Muckleway, gave evidence that a week prior to the murder, Beere had complained of 'illness in his head' and had appeared to be dejected and low. The witness had known Beere for fifteen months

and could only praise his good character and no one seemed able to cast a light on the cause of the sad events.

Beere's mother and father also gave evidence and admitted that there had been a good deal of ill will and jealousy between the women in the Beere family after James had accused his sister of taking money from him. They continued that the marriage to Mary had not been approved of, despite her being described as being 'amiable' and always behaving with great propriety. It took the jury many hours of deliberation to declare that James Beere wilfully murdered his wife and child before committing suicide. He was buried in disgrace in the middle of the night and without a service in the local churchyard. His actions remain a mystery to this day.

The Murders and Suicide at Bath.—The Coroner's jury, after many hours' patient investigation, returned the following verdicts: in the case of James Beere, *felo de se;* in that of the mother and child, *wilful murder* against James Beere, the husband. He was buried according to the late Act provided for such cases, in the church yard, in the night time, but without the usual burial service. A cast has been taken from the head of Beere, which does not by any means develope to a great extent those organs of destructiveness, &c. which phrenologists expect to find prominent in the heads of murderers. It is, however, said to bear a striking resemblance to the head of the celebrated Dr. Dodd.

The *Worcester Journal*, 3 December 1829.

5

CARROTY KATE AND
THE LANSDOWN FAIR (1844)

At Lansdown Fair a gang of the most desperate and inhuman monsters assembled on the Down and committed outrages that would have disgraced a nation of savages. One poor man was knocked down, beaten most unmercifully and robbed of three shillings, the thieves were about to strip him of his clothes but were discovered. As one tradesman was leaving his booth he received a sudden blow on the back of the head and was knocked senseless. One of the gang picked him up and held him in his arms while another of the scoundrels gave him a blow that brought him to the ground a second time; they then stripped him of his coat, trousers, hat and boots and left him for dead on the ground so that when he presented himself in Bath the next day he was blind and bruised from head to foot.

A man from Oldland Common was knocked down at about 5 o'clock on the day of the fair and robbed of 19 sovereigns and some silver. This happened in front of one of the booths and so strong was the gang that no one dared to interfere and the poor man was beaten most shamefully. Several of the ringleaders are known and it is hoped that when they are brought to trial a severe example will be made of the men whose lawless brutality renders them unfit to live in civil society. Five or six respectable individuals were robbed and beaten, some of their coats others of their money hats shoes et cetera.

So ran a newspaper report of August 1832, and this was not the first spot of bother at the annual fair and things were not about to improve. The annual event was held on a high hill to the north of Bath and had originated in the reign of Queen Anne, who granted a charter in 1708. Exactly 100 years later Duncan Campbell, the chief constable, killed a young man while trying to stop an illegal wrestling match – he was convicted of manslaughter and the judge, describing his conduct as 'extremely intemperate', fined him £5 and imprisoned him for three months. Pickpockets abounded as they did at all large events but in 1811, 'a gang of fellows from Gloucestershire armed with bludgeons committed a general assault on the recruiting parties then on the Down, they were dreadfully beaten but forbore to use their sidearms'. The same men returned at night and destroyed the booths.

Poster for Sanger's Circus, 1886.

Perhaps the most sensational commentary on the fair was by 'Lord' George Sanger, a travelling circus owner, in his book *70 Years a Showman*. He does not give a date but the events he describes are almost certainly those of 1844:

Bath at this period had in its slums what was considered to be the most brutish and criminal mob in England, and for these people Lansdown Fair was considered to be their 'night out'. Although it lasted but one day, the fair was always a big one occupying a great space on a broad hillside. As night advanced the character of the fair crowd gradually changed. Fights were frequent and we got news that the Bath roughs were out in force bent on mischief. They were led by a redheaded virago, a dreadful giantess of a woman known as 'Carroty Kate'. She was an awful creature strong as a navvy, a big brutal animal caring nothing for magistrates or jail. With the majority of her followers, she hailed from Bull Paunch Alley, the lowest slum in the city where no policeman ever dared to penetrate and innumerable horrors were committed nightly.

Half stripped with her red hair flying wildly behind her, she incited the gang of ruffians with her to wreck the fair. The drinking booths were the first to suffer. The mob took possession of them, half killed some of the unfortunate owners and then set to work to drink themselves into a state of frenzy. Not content with drinking all they could, the ruffians staved in barrels, turned on taps, and let the liquor run to waste. Then they started to wreck the booths. Canvas was torn to shreds, platforms were smashed up and made bonfires of, wagons were battered and overturned, show fronts that had cost some of the owners small fortunes were battered to fragments. Everywhere was riot ruin and destruction.

PRICE SIXPENCE.

Seventy Years a Showman

BY

"LORD" GEORGE SANGER

C. ARTHUR PEARSON Limited.

An early edition of Sanger's memoirs.

This was undoubtedly the worst year of a habitually troubled event but the hooligans were not to have it all their own way this time.

> ... the showman came together pale with anger, some of them bruised and bleeding from the fray and all resolved on vengeance. They had marked one or two of the ringleaders of the riot and meant to give them a taste of showmen's law [...] some 30 stalwart showmen armed with stout cudgels rode after the retreating mob. Presently they returned trailing with them as prisoners about a dozen men and the terrible woman Carroty Kate with their hands tied behind them. First of all the woman was securely fastened to the wheel of a heavy wagon and was left cursing. With long tent ropes the showman linked the wreckers together by their bound hands. Then a stout rope was thrown across the pond and fastened to the living chain with some 20 men holding the line on the further bank[...] the prisoners were dragged into the pond then back again, spluttering and begging for mercy. No notice was taken of their cries. Out they were dragged and laid on the grass for a few minutes, 'to drain' as someone remarked.

Harsh though the punishment had been, the enraged stallholders were not finished yet. The rioters were stripped to the waist and tied to cart wheels, after which four muscular showmen set about them with new whalebone riding whips. Three dozen lashes apiece was ordered and the terrible sentence carried out before they were released and staggered away down the hill. This left the problem of what to do with Carroty Kate.

'What are you going to do to me?' she raved. Some penny canes were brought out and two strong young women administered a sound thrashing. She screamed and swore horribly but the young women flogged on until they were tired and then the red-haired wretch was allowed to limp away cursing as she went in the most dreadful fashion.

The rioters had their fun, the showman had their revenge, natural justice was served; but that was not to be the end of the matter.

The local press reports differed from the above account in many details and described the arrest of some of the rioters out of an estimated contingent of around fifty, many of whom came from the Kingswood area. Ringleaders were named as Samuel Pool and Stephen Bennet and eleven men were arrested in total including eight who were apprehended at the scene and handed over to the police being described as 'almost frightful to behold, their faces freshly cut and bruised, the hair clotted with blood and their clothes covered with dirt'. They were charged with riotous assembly and two were further charged with a sexual assault upon a girl of seventeen. The eventual charges came down to five felonies,

PROVINCIAL INTELLIGENCE.

SOMERSETSHIRE.

LANSDOWN FAIR.—The fellows charged with the various outrages at the late Lansdown fair, as noticed in our last paper, were again brought up at Chandos-house on Wednesday, when the gang was disposed of by commitments to take their trials at the assize (in March next) for the following offences :—Six felonies, two attempts at violation, two cases of actual violation, and one of assault. The number of cases with which each prisoner stands charged is as follows :—Wm. Fudge, 4 ; Samuel Pullen, 1 ; Samuel Pool, 11 ; Wm. Lacey, jun., 11 ; Stephen Bennett, 7 ; Isaac Allen, 2 ; Thomas Perry, 2 ; Wm. Smith, 1 ; George Jones, 1 ; Peter Britten, 2.
WINCHCOMB.—*Sudden Death.*—On Monday evening a

Bristol Mercury of 24 August 1844.

two attempts at violation, two cases of actual violation and one of assault. Four men faced charges that carried the death penalty.

The case was heard in December and the four were found guilty of felonious assault; the Judge recorded a sentence of death against them as he was bound to do by law but recommended that their lives be spared. The others pleaded guilty to riot and received sentences from between six to eighteen months, all with hard labour. The four further charged with the violation of Ann Holbrook were acquitted to the surprise of the court and their sentences brought in line with the others.

What of the Amazonian ringleader? There is no mention of a Kate, Carroty or otherwise, in any report and the only mention of her existence comes from Sanger himself... once a showman...? The fair died a natural death with the establishment of monthly markets and another large fair which took place over two days in the near vicinity.

Abandon Hope
All Ye...

MARRY IN HASTE... CHARLOTTE MARCHANT AND THE 1849 POISONING

On Saturday 31 March 1849 Henry Marchant, a twenty-eight-year-old quarryman, had a few pints of beer with a fellow workman and made his way home to 13 Angel Place, on the Lower Bristol Road. He arrived home at around midnight and his wife greeted him with a cup of tea. Within about an hour of drinking it he was violently sick and continued to be ill throughout the following Sunday. He returned to his labours at Combe Down on Monday morning but was too ill to carry out his duties and had to return home. On the advice of neighbours, his wife, Charlotte, called Mr Lloyd, the parish surgeon, claiming that her husband had been injured at work.

Poor Henry died on 7 of April and was buried on Friday the 13th. A tragic end to a young and fit man, and there the matter might have ended were it not for the fact that Charlotte married again by licence nine days later on the 16th! She was thirty-two years of age, and her new husband was a seventy-year-old retired gardener named William Harris whose wife had died a few weeks before – in fact she was the second of his wives to have died within the previous thirteen months.

William Beavis, a forty-year-old greengrocer, and his wife Eliza shared the house at Angel Place and ran their shop from the ground floor; the Marchants' occupied the front room on the first floor with their three-year-old child. They were not at all happy with the turn of events having observed that Charlotte and Harris had been seeing each other for up to six weeks before Henry's death, sometimes meeting at the Larkhall Inn. Beavis demanded a post-mortem and inquest into their friend's death, suspecting that he had been poisoned. After an initial refusal, Henry's body was exhumed and its stomach contents were submitted to Mr Herapath, an analytical chemist of Bristol, who found it to contain a considerable amount of arsenic.

A warrant was issued for the arrest of the newlyweds and they were dragged from their bed at 15 Brooklease Buildings, Larkhall, at midnight and conveyed to the city jail where Charlotte remained 'in a fainting state'. She was described as 'far from being of prepossessing features' and appeared much distracted, keeping her head bowed throughout the process. Details from the Description Book at Wilton jail described her as aged thirty-two, of fresh complexion with blue eyes and dark brown hair standing 5 feet 1 inch high, a housewife born in Shepton Mallet.

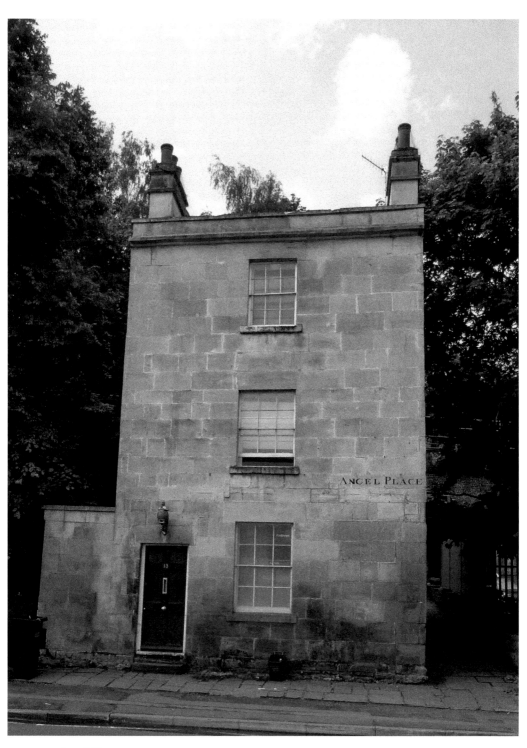

13 Angel Place.

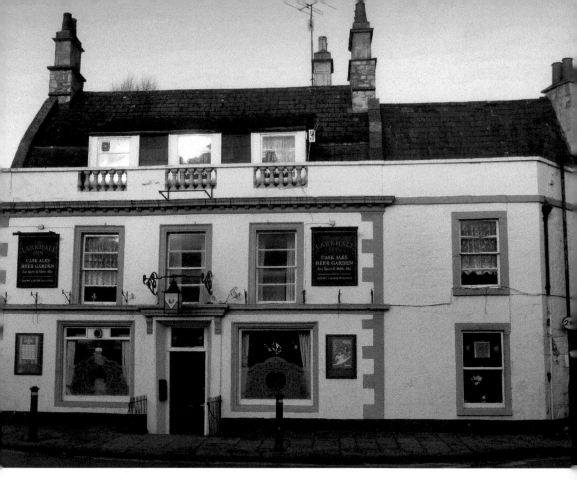

The Larkhall Inn.

A coroner's jury was summoned to the White Hart, Widcombe Hill, to consider the evidence before being adjourned to the Guildhall at the beginning of May. When the court opened there were four prisoners brought up for examination; joining the Harrises were Daniel Sheyler and his wife Hannah who worked for Harris and had been employed to nurse his former wife Louisa. Some details of Harris's life were revealed in the local press. A retired market gardener, he was in receipt of £40 per year from one of his sons in America and had been married to his first wife for more than fifty years during which time they had run a gardening and vegetable business together. She had died just over twelve months before and he married Louisa from whom he had expected to inherit some property, but this turned out to be false and Harris claimed that he had been misled.

Returning to the inquest, Mr Lloyd stated that he found the deceased labouring under an acute disease of the stomach producing excessive vomiting and had prescribed medicines for relieving him; he had been in great pain but the surgeon did not suspect poison.

Another witness claimed that on the day of her husband's death Charlotte had gone out in a new coloured gown with a black velvet bonnet trimmed with white ribbons and said, upon her return, that she had been with an uncle. The

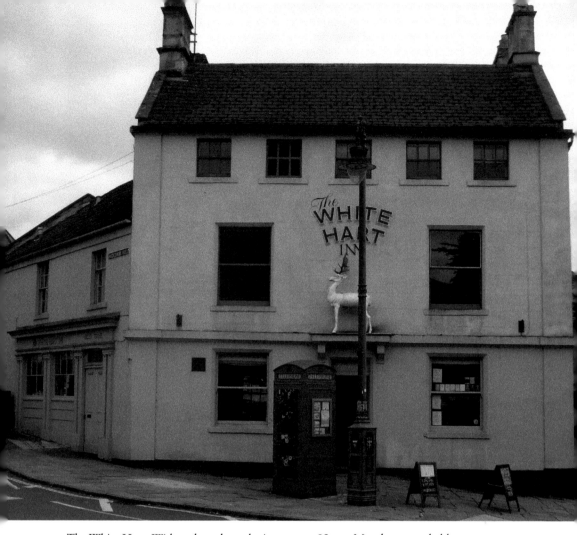

The White Hart, Widcombe, where the inquest on Henry Marchant was held.

Saturday night after the funeral a cart drew up and Mr Sheyler was seen loading up Charlotte's possessions and taking them to 15 Brooklease Buildings, Larkhall, the home of William Harris. Harris stated in evidence that he had no idea that Charlotte was married during the time he was seeing her, believing that she was a respectable widow. He knew nothing of her husband until he heard about his death, but she had told him that she had a sister who was ill. He had sold all his possessions, he claimed, in order to move to America with Charlotte.

William Oakley, chief of police, carried out a search of the Marchant's room and found a paper packet containing a white powder, which proved to contain eighty-three grains of arsenic. This was not as dramatic as it might sound today, as the substance was fairly easily obtained from a chemist and was used against rats and other vermin. Among other articles examined, however, was a teapot that had been scrubbed clean.

William Harris was examined and stated that he believed that his new wife had lived at Widcombe with her sister who she had been nursing but had

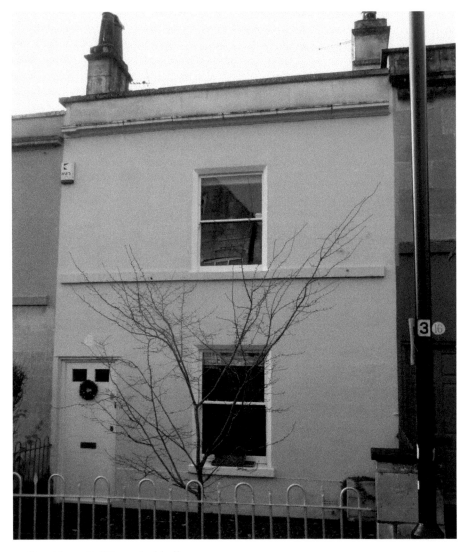

15 Brooklease Buildings, Larkhall.

now died. He believed her to be a widow with a young son and Mrs Sheyler claimed that she believed the same thing, adding that they had both been taken in but Mr Harris was prepared to overlook the matter. The inquest was then adjourned for a week in order to give time for the exhumation and examination of the body of Louisa Harris, the second wife of William Harris, which was exhumed by order of the coroner in early May. Unfortunately, as she had been in the ground for three months, the post-mortem was inconclusive, leaving the jury to conclude that she had died 'by inflammation of the stomach and intestines but that there was no evidence as to what had produced that inflammation'.

Evidence was produced to show that Harris had adopted the habit of asking complete strangers to marry him since the death of his wife, but other than this strange quirk of character there was nothing particularly suspicious in his behaviour to indicate that he had murdered his wife. It is most unfortunate that Charlotte Marchant was inclined to take up his offer and her reasons will now never be known; had she shown some distress or period of mourning after her partner's demise the crime may never have come to light.

Eventually the coroner's jury reached a verdict and declared that 'the deceased, Henry Marchant, had died from the effects of poison feloniously administered to him by his wife Charlotte Harris'. The other prisoners were pronounced 'not guilty' and set at liberty. Charlotte was again too ill to appear in court and was remanded to Wilton jail on 5 August.

At the Crown Court in Bridgewater on Friday 10 August 1849 Charlotte stood alone in the dock in front of Mr Justice Cresswell, but as most of the evidence and witnesses had been heard at the inquest the trial only took two days. The jury retired for an hour to consider the evidence and then returned with a verdict of 'guilty'. Judge Creswell pronounced a sentence of death by hanging with her body to be buried within the confines of the jail, and there the matter may have ended but Charlotte's luck was about to take a turn for the better.

Her barrister, a Mr Saunders, rose to his feet and declared his client to be pregnant, causing great commotion in the court.

His Lordship ordered the doors of the court to be closed and addressing the High Sheriff ordered him at once to empanel a 'jury of matrons' from females within the court, for the purpose of trying the prisoner's plea. A dozen ladies who had entered the court as spectators were then (much against the intimations of some of them) compelled to enter a box and were sworn in by the crier [who outlined their responsibilities]. They would at once retire and perform those duties upon which they had been empanelled. The jury of matrons were then escorted by the High Sheriff to the rear of the court and in a few minutes, they returned and delivered a verdict that the prisoner was with child. – The judge said, 'Let the sentence be respited'. The prisoner, who appeared to be weak from her situation, was then assisted from the bar.

A petition, in those days, was known as a memorial. One was organised asking for a commutation of her sentence, as she was now, as they put it, 'the living mother of a living child biding her time in Wilton jail in order that she may afterwards be hanged to death'. It worked.

Charlotte was sentenced to two years solitary confinement followed by transportation for life. On 4 October 1851 she sailed with 199 others aboard the ship *Anna Maria* to Van Diemen's Land, arriving on 26 January 1852. Records show that on 13 December 1853 she was given permission to marry John Burns,

a free man, and granted a conditional pardon on 9 June 1857. She died in 1862 at the age of forty-four.

The general public and all those involved in the case, including the judge, remained baffled by her strange behaviour. The pair seem to have lived together perfectly happily with their small son, Henry was fit and healthy with a good job, and the family income was supplemented by Charlotte selling oranges in the Bath market. Henry enjoyed a pint of beer with his workmates but there is no suggestion that he was in any way abusive towards his wife.

THE SALE OF POISONS, AND MURDER MADE EASY.

While we were publishing our remarks last week in reference to " Modern Murders," and the astounding atrocity exhibited in deliberate acts of poisoning, a trial was going on that revealed, if possible, even more cold-blooded depravity than that which we then instanced. A daily paper thus alludes to the latter case, the trial and conviction of CHARLOTTE MARCHANT for murder. It will be remembered that she got rid of her husband and immediately afterwards married an old man.

"Considering the several circumstances of this case, and that no insanity was pleaded in behalf of the prisoner, we really think it must be taken as one of the most monstrous upon record We have read of women sacrificing aged husbands for younger paramours, and being led from one criminality to another by accumulated motives of covetousness or passion; but in this case there was neither jealousy nor revenge at work ; there was no impulse of unlawful love or deadly hate, nor any sufficient or credible motive on the score of worldly gain. The woman was well-matched, well-housed, and well-cared for, and yet, for the chance, to all appearance, of marrying a stranger of more than twice her own years, she goes home and deliberately spends a week in killing her husband by a frightful death."

The Era, 12 August 1849.

INFANTICIDE AND SUICIDE: EDMUND HUNT (1850)

Edmund Francis Hunt was born in Bathwick in 1813, the son of a carpenter, and had trained to be a plasterer, a steady industrious man who had been in the service of his master, a Mr Fisher of Charlotte Street, for upwards of twenty years. Sadly, his wife Mary was of a different character. Despite a good home and children, she had been convicted several times of shoplifting and drunkenness, causing Edmund much mental anguish. After her last conviction, for stealing £3.18s worth of silk, was held at the Bath City Sessions on 26 October 1849. She received one months' imprisonment with hard labour. Hunt declared that if she ever disgraced him again in such a fashion he would destroy himself and the children. It was a threat that she did not seem to take very seriously, as on Saturday 2 February of the following year she was again apprehended by the police at home and the house searched for missing items. Edmund received the news from a neighbour as he returned home at around 1.00 a.m. It was payday and he had been drinking with his mates.

Mary was charged with 'Stealing, on the 26th day of January, a piece of black silk containing three handkerchiefs, the property of Samuel Churchill and George Smith valued at fifteen shillings'. She was further charged that on 2 February she stole a piece of silk containing six handkerchiefs to the value of twenty shillings,

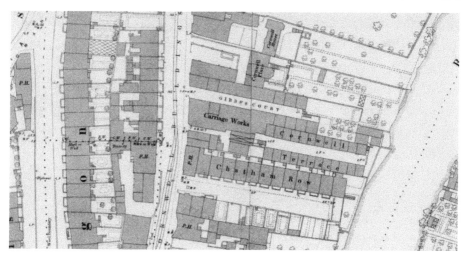

Cornwell Terrace in the 1880s.

property of Thomas Tilly. Their thirteen-year-old son, also Edmund, recalls what happened:

> As soon as father came home he said, 'Where's mother?' I said she had been taken to the station house but I did not know what for. My little sister who was upstairs in bed then called out 'Father' and he told me to go and fetch her. I gave him my sister and he gave her a drop of beer, she was two and a half years old and my only sister, he liked her more than the rest of us and often had her brought downstairs to him when he came home. I went up to bed and fell asleep. On Sunday morning when I came downstairs my father's hat was on the table and the gate leading to the river was wide open. My mother had been taken up before for stealing and my father at these times was almost out of his mind.

The family of seven included two younger boys, Charles and George, and a baby girl, Mary Ann, who had been born in prison during Mary's last sentence. They lived at Cornwell Terrace, Walcot Street, in a house that backed onto the river. Fearing the worst, some neighbours dragged the river and the body of the unfortunate man was pulled from the water around 50 yards below his house. His arms were folded over his chest as if embracing something. The river was very high at the time and it was assumed that the girl, Sarah (Sally), had been washed from her father's arms; the body was found on Monday around 18 miles

MELANCHOLY SUICIDE AND INFANTICIDE.— An unfortunate man, named Edmund Hunt, destroyed his own life and that of his infant child at Bath, on Tuesday se'ennight. From the evidence it appeared that the deceased had a wife who was arrested on several occasions for shoplifting. On going home on the evening in question, and on learning the misfortune that had again befallen him, he drowned himself and his child in the river Avon. The wretched man was about thirty-seven years of age, and bore the highest character for sobriety and honesty. He was passionately attached to the infant in question. The jury returned a verdict of " temporary insanity."

Nairnshire Mirror, 23 February 1850.

below the spot where it had happened. At the coroner's inquest held at The Bell Inn, Walcot Street, the jury returned a verdict that 'The deceased drowned himself while labouring under temporary insanity.'

Mary Hunt, now a widow, aged thirty-eight, was tried at Bath Quarter Sessions on 8 April 1850. She was entered in the prison description book as 4 feet 11 inches with a fresh complexion, an oval head, brown sandy hair, brown eyes and a double chin. She was able to read and her occupation was given as 'good needlewoman' and her 'Native Place' as Heligoland.

She was accused of the offences listed above, having gone into various shops asking to look at silk handkerchiefs, some of which she removed without paying and took to the pawnshop. The Recorder, in passing sentence, observed that he had never known a more disgraceful or distressing case than this. The prisoner had not committed theft from want and had been sentenced before on a similar charge; no sooner had she been released from prison than she repeated the offence. Mary Hunt, who had her baby girl at her breast, was sentenced to be transported for ten years.

The Bell Inn, Walcot, in 2021.

She set sail from London on 25 October 1850, with 172 other convicts aboard the *Emma Eugenia* for Van Diemen's Land, described as a widow with four children, one of whom, a daughter named Mary Ann, fifteen months old, was with her on the ship – her three boys had been sent to the Bath Union Workhouse. She arrived in what is now Tasmania on 7 March 1851 and one year later on 1 March 1852 she married a William Jarvis. Female convicts were assigned as servants in free settler households or sent to a 'female factory', a women's prison workhouse of which there were five in Van Diemen's Land.

Her conduct must have been good because on 16 May 1854 she was recommended for a conditional pardon, which would give her the freedom of the colony but not allow her to return to England. Mary was told that she must serve five years and was eventually pardoned on 3 April 1855 after which the little family disappeared from sight.

8

A CASE OF POISONING? LEWIS AND CROSBY (1851)

Mrs Searle answered a knock at the door to her husband's chemist shop at 28 Claverton Street, Bath, and saw a young respectable-looking woman who was heavily pregnant. The young woman introduced herself as Mrs Slater and announced that she had come in response to an advert for lodgings to rent. Finding the premises agreeable, she and Mr Slater moved in on 7 June 1851. The following Tuesday, 10 June, she gave birth to a daughter whom they named Elizabeth. Before long Mary Searle and Mrs Slater became good friends, so much so that when on 4 July the lodgers left the premises and moved to London they left their daughter in her full-time care agreeing to pay £1 per week for her care and upkeep. The Searles had four daughters of their own, ranging in age from two to eleven, so the decision to leave little Elizabeth in their care was perhaps not that unusual.

The couple returned to Bath on a number of occasions and, after one visit on 1 August, the child became unwell and restless, which Mr Searle put down to a chest infection. He administered a powder and the child improved within a day or so. Although a very fussy eater, little Elizabeth soon improved but after another visit by her mother Elizabeth, became ill once more with violent sickness and diarrhoea. The same occurred after subsequent visits and Mrs Searle became increasingly concerned but found it inconceivable that Mrs Slater would be poisoning her own baby. Nonetheless she felt that she had to do something and asked the advice of a local surgeon, Dr Lawrence, at the same time giving him two teats that had been used on her feeding bottle so that he could examine them. Meanwhile, the child was sent off to Hilperton in Wiltshire for a 'change of air', much to Mrs Searle's annoyance; she described the move as unnecessary and demanded that Elizabeth be brought back, which was done.

Elizabeth's health continued to deteriorate and in early October Mrs Searle communicated her fears to the police, giving rise to a rather farcical situation in which two police officers hid in the chemist shop, which had a view into the parlour, while Mrs Slater was with Elizabeth, but by the time they were in position mother and child had moved upstairs. As on previous occasions, the child became violently sick and Mrs Slater was taken into custody. She was searched at the station but nothing incriminating was found.

Baby Elizabeth died on 11 October at the age of four months. A post-mortem examination was carried out by Dr Lawrence who found the child underweight

The Chemist's Shop in Claverton Street.

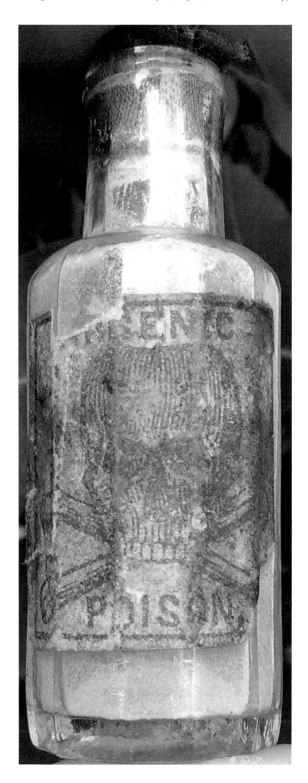

Victorian arsenic bottle.

and emaciated with her internal organs inflamed, consistent with her having consumed small amounts of arsenic over a period of time. This was confirmed by Professor William Herapath, one of the foremost toxicologists of the time. The two teats had now been examined and were found to contain some small crystals, which also proved positive for arsenic.

The investigation was now a case of murder and the spotlight was turned upon the parents, 'Mr and Mrs Slater', with devastating effect. 'Mrs Slater' was in reality Elizabeth Catherine Lewis from a respectable family in Bristol and a governess by profession. She had worked as such in the West Indies and Elizabeth was not her first child – she also had a toddler allegedly fathered by a wealthy man in Barbados. 'Mr Slater' was in reality Thomas Crosby, a wealthy solicitor from Stoke Bishop, also in Bristol, a married man aged fifty with a wife and three grown-up children of his own.

Charged with murder, the pair were sent for trial at the Taunton Assizes on 5 April 1852 in front of Mr Justice William Erle and the case was opened by Inspector Norris who, after outlining the facts, gave evidence that no trace of arsenic was found on the person of Miss Lewis nor was there anything at her home in Redland, Bristol, where she lived with her mother and sister. Professor Herapath gave evidence to say that it was possible to detect traces of the minutest part of arsenic and had the prisoner any on her fingers it would have transferred to her gloves – but nothing was found.

In cross-examination Mrs Searle agreed that she assisted and dispensed medicines from the shop occasionally and that she had used items from there to try to assist in little Elizabeth's eating problems. She also agreed that the wrong medicines had been dispensed on occasions and one mistake had burnt a child's mouth severely. When cross-examined James Searle denied that he had been advised by a colleague to destroy some drugs that had been dangerously mixed up. It also emerged that the teats for the feeding bottle were obtained from the shop. Justice Erle summed up and the jury returned almost immediately with a not guilty verdict.

The jury's verdict was almost certainly correct. It was only the Searles who attributed Elizabeth's recurring bouts of illness to visits from the mother, possibly discerning the reality of the situation once the child was seriously ill and seeking to deflect the blame. The doubts cast upon James Searle's professionalism as a chemist and the fact that he kept arsenic on the premises are too much of a coincidence to be discounted. It was generally agreed that both prisoners came from respectable backgrounds and had been most concerned over the welfare of the child, having shown great affection towards her. Neither had any motive for wanting her dead and it was probably a tragic accident caused by unprofessional habits in the chemist's shop.

Thomas Crosby's family were not mentioned at the trial and it is interesting to speculate whether they knew about his secret lover and child before the arrest made the situation common knowledge. What became of Elizabeth Lewis is not

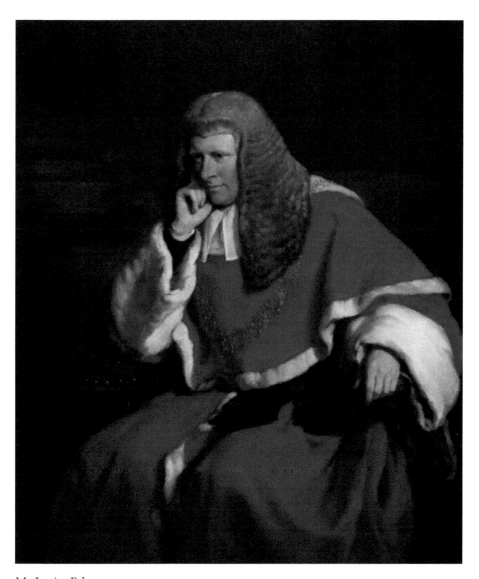

Mr Justice Erle.

known but the census return for 1861 has Thomas Crosby, attorney at law, now a widower aged fifty nine, living with daughter Julia and married son Harry at Clifton in Bristol. James and Mary Searle had by this time moved back to his home county of Cornwall where he continued his profession, opening a chemist shop in Tavistock.

9

HENRY AND MARY FISHER: A SUICIDE PACT (1865)

On the afternoon of Friday 6 January 1865 Mary Fisher was becoming worried. She had not seen her stepson Henry Fisher or his wife, also Mary, for some time and decided to call around to their home at 2 Northampton Street to make sure that everything was okay. After knocking for a considerable time the door was answered by Henry who looked very ill and drawn. She asked him what was wrong. 'We couldn't help it,' he replied, 'We have taken laudanum, we did it by mutual consent.' Entering the house, she saw Mary lying insensible in bed, two tumbler glasses on the table, both of which, she determined, had contained opium.

Henry Fisher was a journeyman shoemaker by trade around forty-eight years old, born and bred in Bath. His wife was a couple of years older than him and came from Wiltshire. She worked with her husband as a shoe binder.

Although married for fifteen years, the pair had produced only one child who had died at a young age and the couple tended to feed off each other's despondency; they were in constant fear of ending up in the workhouse and afraid of machinery taking over their trade. His step-mother often found them tearful and low-spirited. They had often expressed a desire to die together she said, but she had not taken them seriously. 'We worked each other up to it,' claimed Henry, and when asked how much they had taken he replied that they had sat by the fire and cried before taking eleven spoonfuls of laudanum each topped up with a small amount of porter. The opium they had accumulated over time, making purchases in small doses until they thought they had sufficient to kill themselves. Henry took his first and did not actually see his wife take hers but heard her swallowing it. They then embraced each other and retired to bed.

Mary summoned Dr Massey, who ordered that Henry be sent immediately to hospital – why he did not send Mary as well was never explained and she was left in the house still insensible. Massey and her mother-in-law were in constant attendance and she continued in this state throughout Saturday, finally dying on Sunday morning.

The inquest on Mary Fisher was held at the White Horse Tavern at 4 Northampton Street next to their home, where it emerged that Henry had a history of mental illness and was in the mental ward of the Bath workhouse in around 1848. After that he was taken in and looked after by his uncle but had to be constantly watched as they were afraid of him harming himself. Dr Massey

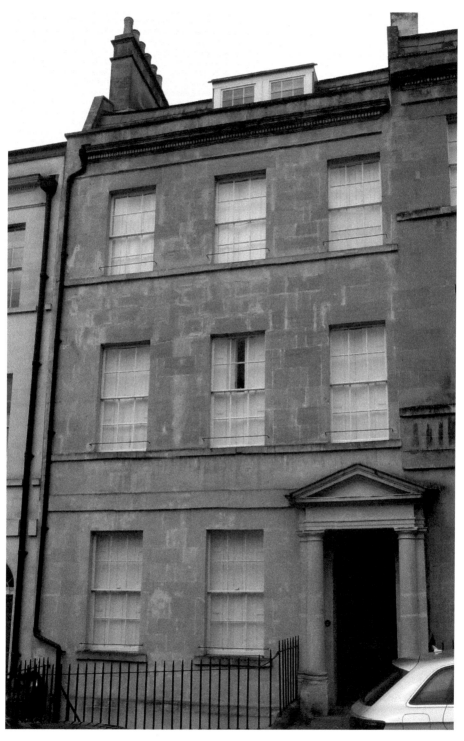

The White Horse in 2021, where the inquest was held.

gave evidence to say that the deceased was very pale and cadaverous when he saw her and it proved impossible to rouse her as she had fallen into a coma, otherwise she appeared to be perfectly healthy; death was caused by opium poisoning. The life of Henry Fisher had been saved because he was sick before the drug could take full effect.

Witnesses were called to say that Mary was often in a very depressed state and had once said, 'I wish we could die together and be found dead tomorrow morning.' She had often expressed similar sentiments to friends and family while seemingly quite sober and in her right mind.

The coroner gave his opinion to the jury that this evidence was strongly in favour of the deceased knowing what she was doing and that the pair were acting in concert. The jury retired for half an hour before bringing in a verdict of *felo de se* (suicide) against Mary and a verdict of 'wilful murder' against Henry for causing her death! Such was the law at that time.

The Old Bath police station, 1865.

Poor Henry was placed on remand and appeared at the Bath Police Court on Saturday 21 January charged with wilful murder. In court he stated that he and his wife had assisted each other in procuring the poison and said in answer to the charge, 'According to my notion, sir, I am not guilty of murder. The case is the same as many other cases of poor weak-minded people taking the agreement to die together. It is of no use me saying anything else. You see how it has turned out and I leave the case in your hands.' He was remanded for trial at the Spring Assizes in Taunton at the end of March before Mr Justice Crompton. Henry gave evidence much as he had at the police court and it was stated that the couple were very much devoted to each other, with Mary having a dominant role controlling the finances and he was happy to do whatever she decided. This view may, of course, be the defence trying to absolve Henry from blame. The judge, in his summing-up, observed that it might be regretted that there were not different punishments for different degrees of murder, but the law was clear and the facts were not in dispute. The jury deliberated for less than half an hour and had little choice but to bring in a verdict of guilty of murder but, echoing the judge's sentiments, they put in a strong recommendation for mercy.

Clement Street, demolished 1964.

The judge put on the black cap and told the prisoner that he had been properly convicted of murder and an act of parliament commanded that he should pass judgement of death. The jury had recommended him to mercy and he should join in that recommendation but he had no power to pass any other sentence. There are many points in this case which led him to hope that mercy would be extended to him, as it was clear that he was a man of weak mind and much under the influence of his wife. The prisoner, it was reported, looked the very picture of misery and despondency.

Luckily, in this case, all was not lost and the recommendations of both judge and jury were listened to. It was decided that there were good grounds for believing that Henry was insane and his sentence was rescinded, although what sentence he received in its place seems to have gone unreported. By the 1871 census he was aged fifty-four and living with the Browning family at 7 Clement Street, Walcot. They followed Henry's trade of boot and shoe making and so presumably he had found employment with a sympathetic family.

THE FALL OF WIDCOMBE BRIDGE (1877)

Bath's Halfpenny Bridge spans the River Avon connecting Lyncombe and Widcombe to the city centre and the Great Western Railway station. The first bridge in this location was built in 1863 by Hicks & Isaacs and opened on 5 March; it was a 100-foot-long, 9-foot-wide timber double-bowstring truss bridge. Like many bridges with the same name, Halfpenny Bridge was a pedestrian toll bridge charging half a penny per person, which gave it its name. It gave quick access from Widcombe to Bath station.

On Wednesday 6 June 1877 disaster struck when hundreds of tourists alighted from the 10.47 a.m. train coming from the Weymouth and Salisbury area to go to the Bath and West Show, a yearly agricultural exhibition celebrating its 100th anniversary. The day-trippers surged onto the narrow footbridge but the toll

The southern entrance of Bath Spa station.

house was nearest to the showground on the Widcombe side the opposite end to the railway station, meaning the mass of people paid to get off the bridge rather than onto it. In normal times the flow would probably have been equal in both directions. This unprecedented event led to large queues of people waiting on the bridge while their half pennies were collected by the single toll keeper assisted by his daughter.

The bridge was seriously overloaded and suddenly the middle gave way with a great crack, plunging between 100 and 200 people some 30 feet into the river below; some landed on the stone pavement or the quay wall, which ran alongside the river, others clung desperately to the collapsing timber frame. There were

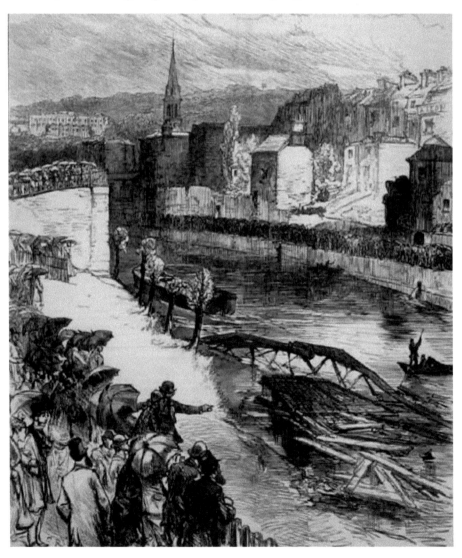

A contemporary view of the disaster.

eight immediate deaths and over fifty injuries. It appeared that the Widcombe half was the first to give way and that section rested for a few seconds on the towpath, which runs underneath the bridge, allowing valuable time for a few people to escape.

Spectators and those nearby leapt into action, some diving into the water to rescue people, some dragging survivors onto pleasure boats, which were quickly launched from nearby boathouses. Three railway workers tangled ropes over the edge and pulled people to safety. The *Bath Chronicle* for the following day published a list of the dead and injured along with their place of origin as far as was known at the time.

An inquest was opened on 8 June by the coroner, Mr A. H. English, by which time eight bodies had been recovered with dozens more people lying injured in the Royal United Hospital in Bath, some of whom were not expected to survive. It was feared that more people may have been washed further down the river, a section of which was drained to look for more bodies. Several people were reported missing, including two men from London, but despite these fears the total estimated to have died was only twelve, remarkable considering the circumstances. The bridge was privately owned and had been extensively repaired only the year before.

There was a government enquiry under Colonel Yolland, a Board of Trade inspector at the Guildhall, which took place over many days during which the state of the bridge and its repairs were gone into with great detail, revealing that parts were rotten but not bad enough to have caused the accident. Henry Tanner, the toll keeper, was questioned about the cause of the delay and asked if it was as a result of him haggling over change of a shilling, causing a massive backlog as some witnesses had claimed. He denied this, saying that the giving of change

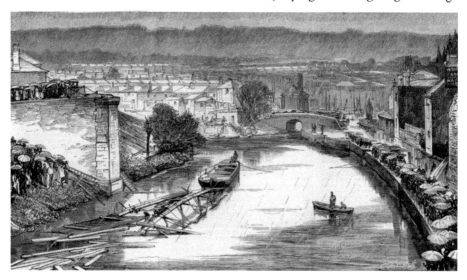

Looking for survivors.

The toll house looking south.

was handled by his daughter who was assisting him. It was also said that one man was so worried about the huge weight on the structure that he drew a handful of sovereigns from his pocket and offered to pay for everyone to cross; Tanner hotly denied that this had occurred. He further denied that he was counting the money shortly after the collapse and said that he was knocked unconscious and remained so for some time, adding that he had not been told to expect a large number of people going to the show on that day, although it would have been thought pretty obvious.

The bridge builder and carpenter Mr James Williams estimated that when built the bridge would hold 200 to 300 people without collapsing or 25 tonnes if distributed equally.

Despite the jury returning a verdict of manslaughter against the bridge owners and the toll keeper, the jury at the next Somerset Assizes determined that there was no case to answer. The charges were dismissed and nobody was convicted of an offence.

Later the same year, a new bridge was designed by T. E. M. Marsh, replacing the old one with a graceful single-span wrought-iron lattice girder structure using the same piers that survive to this day.

The toll house and new bridge looking north.

The elegant Halfpenny Bridge in 2019.

11
BATTLEFIELD BATH (1882)

During January 1882 a middle-aged man named William Laycock was summoned to court at the insistence of William Powell, a captain in the Salvation Army then based at St James Hall, 2 Newark Street. Powell's claim was that Laycock had disturbed a congregation assembled for religious purposes on Friday 13th. Powell, a much younger man, said that he was an evangelist and was connected with the salvation barracks, a registered place of worship in Newark Street. The defendant, he claimed, made use of obscene language and by his conduct delayed the service so that a police officer had to be summoned before he would leave the room. This was not the first time that he had done this and he had also appeared at the prosecutor's lodgings and caused him considerable annoyance. Laycock was allowed to question Powell and asked,

> May I ask what is your trade?
> I am an evangelist
> Is not your profession that of a clown?
> I was formally a clown
> How long since where are you a clown?

This fascinating line of enquiry was curtailed by the magistrate who interrupted with,

> That does not matter to you, it does not concern you whether he was a clown yesterday.

Other witnesses were called who gave evidence that once ejected, Laycock, the defendant, continued his abuse calling them all 'sneaks' and 'swine'. Laycock admitted that he had been drinking and claimed that he was evicted because he had not contributed to the collection. He was bound over to keep the peace for a month.

This was not the first nor the last time that Captain Powell was to appear before the courts. In March he summoned a young man named Sergeant for causing a disturbance, he was acquitted but as the salvationists left the court they were followed by a mob of several hundred men and boys and a bag of flour was thrown which covered them. They had to be rescued by the police and escorted home. The magistrates were getting pretty annoyed with such trivial cases causing such chaos – not only that but it seems that Bath was soon blessed with not one Salvation Army but two! General Booth's 'official' army moved into

St James Hall, Newark Street, in the 1880s.

a large warehouse at Ambury in the city in March, but this didn't worry Captain Powell, who in May appeared at a police court in Chippenham charged with obstruction. In his pursuit of the official army he had:

> for some months held the town, annoying the inhabitants because of roughs who paraded the streets displaying banners and playing rough music[...] Captain Powell, a converted clown, with his Hallelujah Banjo Band and his Trumpeter General gave the town the appearance of a fair day on the sabbath despite police instructions not to assemble.

By April the 'official' army was using the chapel in Argyll Street for some of its meetings and there was much conflict between the rival factions, so much so that a meeting of magistrates in May instructed the superintendent of police to caution the rivals that if they continued to hold processions they would be proceeded against. Booth called this off but Powell continued to march and some arrests were made including a Frances Morris who when arrested for assaulting a police officer explained his possession of a short stick by claiming that it was 'for fancy' and to keep his hands out of his pockets. He was awarded three weeks' hard labour.

Above: Newark
Street in 2021.

Right: Argyle
Congregational
Chapel.

Later in the year and back in Newark Street, the local inhabitants, tired of all the noise and commotion, had had enough and decided to make some noise of their own:

> They were summoned and fined for interfering with acts of worship. They blew a steam whistle, rang bells and beat a gong so that the services had to be abandoned. They also made a hole in the wall beneath the platform and when a man's arm came through the hole ringing a bell the army captured him. Soon afterwards 40 of the inhabitants of Newark Street presented a memorial to the magistrates complaining of the nuisance caused by the Salvation Army... caused by brass instruments, yelling and shouting at each service of which there were nine or 10 every week with a drum beaten 30 or 40 times per minute.

The petition was successful and the inhabitants grateful 'to have restored to us the blessing of a quiet sabbath'.

As though having two rival armies in the city wasn't enough there was a third desperate to get in on the fun.

ILLUSTRATIONS OF INTEMPERANCE.

Pay-Tables at Public-Houses.

'Tis blue Saturday night! Poor *Tympan* looks queer
Before the Pay-table, and proud Overseer,
In Co. with old *Squeeze'em*, the needful to stop
Of half his week's earnings—to settle *a mop*.
For the poor wife and child standing by, we are led
To mourn o'er the curse that deprives them of bread;
And wish speedy end to these *jobbing carouses*
By which men are lur'd to, and robb'd at, Beer-houses;
Their honest industry all thrown into *pye*,
While foremen and landlords share snacks on the sly. R. G. I.

An early warning against the evils of drink.

Above: The Temperance
Hall, Claverton Street,
Widcombe.

Right: Masthead of
the Skeleton Army
news-sheet.

The Salvation Army had been formed in London in 1865 by a former Methodist
minister, William Booth, and their mission, as they saw it, was to bring salvation
to the poor and destitute by administering to their physical and spiritual needs.

The Army's approach was summed up by Booth – who bestowed upon himself
the title of General – as the three 'S's: Soup, Soap and Salvation. In pursuit of

potential members for their congregation – addicts, prostitutes and alcoholics – their quest took them to anywhere that alcohol was served or sold. This, unsurprisingly, brought Booth and his 'soldiers' into conflict with pub landlords and other purveyors of the 'evil' liquid, as well as those souls not wishing to be saved from their vices.

Before long, this opposition manifested itself in organised groups that, although localised, quickly became known nationally as the Skeleton Army. In deliberate antagonism, they also based themselves along militaristic lines, with their flags adorned with the skull and crossbones and inscribed, in mockery of the salvationists' three 'S's, with three 'B's: Beef; Beer; and Bacca!

The sole aim of the Skeleton Armies was to confront and disrupt Salvationist's activities wherever and whenever they surfaced and it was only a matter of time before confrontations turned violent. One such incident occurred in January 1882, in Sheffield, where a riot ensued. A year later, another took place in London. As the Salvation Army marched through Bethnal Green, they were pelted by an array of missiles – flour, rotten eggs, stones, bricks – and many of its members were beaten.

Frome *War Cry*, the Salvationist paper.

Their way of conducting themselves was seldom appreciated by the local populations, causing one correspondent to write, 'the miserable abortion of fanaticism and humbug under which they travel through our streets, making the night hideous with their impious clamouring's and howls and vilely desecrating the sabbath, calls for the attention of the police. Their wild and insane methods appeal only to the ignorant and those of feeble mind.'

It wasn't long before the Skeleton Army organised itself in Bath and in September 1882 Henry Russell, a young plasterer, was arrested for being part of a mob of 300 or 400 yelling and shouting in the streets; two other lads were charged with assaulting the salvationists in Union Street. They were all fined. Some months later in March 1883, nineteen-year-old Thomas Stevens of Larkhall, describing himself as 'acting captain of the skeleton army', was convicted of throwing snowballs during a Salvation Army parade and fined ten shillings and sixpence.

Compared to other areas in the West Country, Bath got off lightly; there were riots in Weston-super-Mare, Yeovil, Newbury, Exeter, Honiton, Frome, Wells and other towns throughout the country.

A Good Night Out.

A DISTINGUISHED VISITOR:
WILLIAM MARWOOD (1883)

On Monday 30 January 1882, a distinguished-looking gentleman in his sixties stepped off the train at Bath Spa station. He had just come from Devizes and was hoping to spend a pleasant few hours looking around the city before returning to his home in Lincolnshire, but unfortunately this was not to be. He was recognised by a fellow passenger, who pointed him out with great excitement to those on the station platform, and a crowd quickly gathered and began to follow him. He dashed across a footbridge, which at the time connected the station to the Royal Hotel at first-floor level, and after a short time proceeded towards the abbey, but the crowd had grown so large that he was invited by the chief of police to take refuge in the Orange Grove police station before making his way home via Midland station once things had quietened down.

William Marwood in
later years.

Who was this celebrity? William Marwood, the official hangman of England who was returning from Devizes jail where he had just dispatched Charles Gerrish, aged seventy, for the murder of Stephen Coleman, aged seventy-seven.

On 24 November 1881 Coleman and Gerrish, inmates at the Devizes Workhouse, were sitting in the 'old men's room' after breakfast when a quarrel arose between them as to the position of the stall by the fire. Gerrish moved it from its usual position further towards the fire and Coleman objected saying that it would keep the heat from reaching the rest of the room. An argument broke out between them and Coleman, apparently conceding defeat, got up and moved to the other side of the room without saying anything and sat quietly smoking his pipe.

Gerrish then put the poker into the fire for five or six minutes until it was red hot, took it over to Coleman and thrust it into his neck just below the ear severing a principal artery and pouring blood into his windpipe, causing death by suffocation. Coleman was dead within three minutes.

At his trial Gerrish seemed disinterested in his fate, vaguely offering a defence that Coleman had pulled a knife on him but not really bothering to defend himself. The verdict was a foregone conclusion, and on 13 January 1882 Lord Chief Justice Coleridge sentenced him to death at the Wiltshire Assizes. Owing to the callous nature of the crime little attempt was made to petition for his life despite his age.

www.workhouses.org.uk

The workhouse at Devizes.

He was hanged on Monday 30 January 1882 and it was reported that he displayed the utmost indifference to his fate and not the least sign of remorse, eating and sleeping well. On the appointed day the prison chapel bell commenced tolling at around 7.45, and ten minutes later the procession, headed by the prison governor, emerged from the main building and proceeded to the scaffold in the courtyard. Gerrish walked firmly as though going for a stroll and ascended the steps to the scaffold seemingly quite unmoved. During the time that his legs were being pinioned and the rope adjusted his only action was to glance around at the small number of spectators. Marwood then covered his face and a minute later the bolt was drawn and the deadly silence was broken by the clang of the trapdoor and the dull thud of the rope. The condemned man fell a depth of 10 feet and not the slightest movement was made by Gerrish, 'the hands not even being clenched' reported a contemporary account. Death was instantaneous. The body hung for an hour before it was cut down and the black flag hoisted. This was the first execution within the walls of Devizes jail and the scaffold had been erected especially for it.

Marwood was famed as the inventor of the 'long drop,' which ensured that the prisoner's neck was broken instantly at the end of the drop, a method considered more humane than the slow death by strangulation caused by the short 'drop' method – this was particularly distressing to prison governors and staff who were required to witness executions at close quarters despite the abolition of public executions in 1868. Marwood, a former shoemaker, came late to the trade at the age of fifty-four, taking over from William Calcraft, and remained in the job for nine years, hanging 176 people including Charles Peace, the notorious burglar and murderer, and five members of the Irish National Invincibles for murder in Dublin in 1883. Marwood died in 1883 at the age of sixty-four. He was succeeded by James Berry.

13

JACK, I WILL DO FOR THEE...
THE MURDER OF ALBERT MILES (1884)

Labourer and wood-hawker Charles Kite met fellow labourer and part-time fish seller Albert Miles at the Malt and Hops pub in Corn Street on Wednesday 2 January 1884. Miles lived nearby at 5 Bolwell's Court and they were both regulars. Kite had been in and out of the pub three or four times already that morning. The two met up in the pub at about 4.00 p.m. and sat among some of the other regulars, conversation flowing without incident. After a while, according to landlord Frederick Smith, the two appeared to be 'chafing' each other or winding each other up and from there the argument seemed to escalate. From what could be understood of the conversation, each seemed to be accusing the other of crimes that they had committed but had not been called to account for. Smith heard Kite say to Miles, 'If the police knew as much as I do you would be in Shepton jail tonight' and the argument became more heated and when 'bad language' began to be used Smith asked the pair to pack it in or leave.

Miles was always known as 'Jack' and Kite was heard to say to him, 'Jack I will do for thee before tonight.' The two men then left the pub and at least one of the witnesses saw a knife in Kite's hand. They returned after around ten minutes and seemed to have quietened down. Miles was eating a hot potato and it appeared that he was keen to forget the argument and for the two of them to continue with the evening together. Various witnesses gave evidence to say that, although there were strong words between the two, it didn't seem too serious and neither of them appeared drunk. Miles was heard to say, 'What harm have I done to you my son?' and didn't act as though he felt himself threatened.

They tried to order more drinks but were refused as, even though they were both sober, the landlord did not like the language or their arguing. Miles proposed to Kite that they shake hands and was heard to say, 'We'll shake hands Charlie then perhaps the governor will let us have something and we will drink together.' With the potato in his right-hand Miles extended his left towards Kite who seemed reluctant but did likewise, his right hand being in his pocket.

When Kite withdrew his hand it contained an open paring knife which he thrust into the upper part of Miles's chest with the words 'Take that you ____!' He then ran from the pub before anyone could stop him. Miles fell back into the arms of a customer, exclaiming, 'Good God I am stabbed!' They were the last words he ever uttered, and within four minutes he was dead. A surgeon was fetched from the Royal United Hospital but there was nothing he could do. The police had by now

The former Malt & Hops in 2021.

obtained Kite's address and went around to find him at home in an upstairs room in the Lamb and Lion Yard, Lower Borough Walls, lying on a sofa.

They met his father, also Charles, who was drunk and in possession of the knife, which he was reluctant to give up. Charles the younger was taken to Bath Central police station and, when questioned, he denied all knowledge of the affair, saying that he 'knew no more of the matter than the dead in the grave'.

The inquest on the body of Albert Miles, aged twenty-one, was held on the following Wednesday at Bath Guildhall. The surgeon from the local hospital performed the post-mortem and determined that the wound to the skin was slightly over half an inch in length and that the weapon had passed between the first and second ribs at the junction with the breastbone and had punctured the main artery that comes from the heart; the cause of death was compression of the heart and internal haemorrhage.

The case was heard at the Taunton Assizes on 2 February 1884 before Mr Justice Cave where the various witnesses were examined. The basic facts were not in dispute and all the defence could say was that Kite had acted under extreme provocation and that the charge should be one of manslaughter rather

Above: The Lamb & Lion in 2021.

Right: The Guildhall, Bath.

Shire Hall, Taunton, scene of the Assizes from 1858.

than murder. Miles was a much bigger and stronger man than Kite, who struck out in fear not intending to cause serious harm. The jury were not impressed and after a short adjournment found him guilty but with a recommendation for mercy. Justice Cave donned his black cap and pronounced sentence of death upon Kite who was described as looking 'dazed'. Back in jail he was attended by two warders night and day, still denying all memory of the event and 'seems scarcely even now to realise the position in which he is placed'.

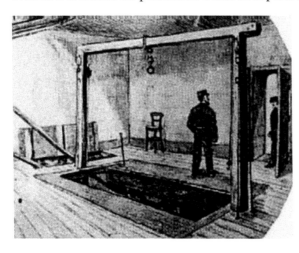

The Last Few Steps...

The case was closely followed, covering many column inches in the local press, and there was much sympathy for his plight, so much so that a petition was organised and a meeting held at the Guildhall. The main points were that he came from a background of drunkenness and poverty, he was under the influence of drink when the act occurred, there was no monetary gain or discernible motive for the killing, and he was not a hardened criminal. The meeting was supported by the mayor and by Edward Payne, the magistrate's clerk. A letter asking that the conviction be reduced to one of manslaughter signed by 1,273 people was sent off to the Home Secretary but to no avail. Kite's execution took place on Monday 25 February at 8.00 a.m. and was carried out by Bartholomew Binns, an incompetent drunk who, because of Kite's small stature, favoured a long drop of 9 feet. Kite walked to the scaffold with a firm step but did not die well; rather than a quick snap of the neck, which would have resulted in an instantaneous death, the victim was slowly asphyxiated over a period of five minutes and, after hanging for an hour, the body was taken down and a post-mortem performed, after which it was declared that 'the execution was properly carried out'.

14

THE ARREST OF MILSOME AND FOWLER (1896)

On 14 February 1896, a gardener in the employ of seventy-nine-year-old retired engineer Henry Smith arrived for work at Muswell Lodge, Tetherdown in Hornsey, North London, to find his master lying dead on the kitchen floor. Smith lived alone and although he had staff in the daytime he was unattended at night and had mantraps and various devices around the grounds to deter intruders. When found he was dressed only in his nightshirt with his arms and legs tied, his head frightfully mutilated. The supposition was that he was in bed when he heard some noise downstairs and went to investigate. Despite his age he was fit and heavily built and seems to have put up a terrific struggle before being killed with a blow to the head. Several rooms had been ransacked, and a large iron safe had been opened and its contents taken. Smith was a noted and somewhat reclusive eccentric and, inevitably, there were rumours that he had a large amount of money in the house; initially sovereigns to the value of £800 were believed to be missing. The burglary was very professional with the alarms and a gun connected to tripwires disconnected.

The police had little to go on except a small lantern and a brass tobacco box found at the scene. Inspectors Marshall and Nutkins from Scotland Yard were put in charge and there was little progress initially but, inevitably in such a high-profile case, rumours began to circulate about two well-known villains from Southam Street in the slums of Notting Hill. Rumours led to the observation and questioning of local people and their associates, and it emerged that the pair had just equipped themselves with new suits of clothes paid for with sovereigns and that they seemed to have plenty of money. There were witnesses from Muswell Hill who had seen them in the area and picked them out at an identity parade.

Albert Milsome, a labourer, lived at 133 Southam Street, North Kensington, with his wife Emily and two children. He had served a number of terms of imprisonment, including two stretches of five years for burglary. Described as 5 feet 5 inches tall, of dark complexion, brown hair, hazel eyes and thin features, he was a stoker by occupation.

Henry Fowler was by far the more powerful personality of the two, and had also served various terms for burglary. He didn't seem to have any family or fixed abode, or if he did it was never discovered. He was described as 5 feet 10 inches tall, of fresh complexion, dark brown hair, brown eyes with a mole on the left side of his nose, and was a billiard marker.

Above: Muswell Lodge, the scene of the crime.

Right: Mr Henry Smith.

Both of the well-known burglars had left the area soon after the murder, which aroused the suspicions of the police. Milsome's sixteen-year-old brother-in-law had a small lantern, which had disappeared at around the time of the murder and he identified it as the one found in Muswell Hill. By 28 March, Chief Inspector Marshall was convinced that Milsome and Fowler had committed the crime and the hunt was on. Marshall traced them to Liverpool, Swindon, Chippenham, Bristol, 'other places' and on to Bath. It emerged that the men were together in a small travelling waxwork that journeyed to fairs around the country, with Fowler acting as the circus strongman.

They were eventually traced to a room at 36 Monmouth Street, where Inspector Marshall with Nutkins and others kept observation. On Sunday 12th at around 11 p.m. he saw the two suspects go into their room with some companions. A number of officers, including Chief Inspector Noble and Inspector Newport of the Bath police, burst into the room. In his evidence Marshall explained:

Nutkins shouted, 'Hands up!' and I shouted that we were police. Nutkins made for Milsome and I made for Fowler. The room [was] very poorly lighted and we could not see very much. Another officer or two seized him almost instantly and

Monmouth Street in 2021.

he became desperate. He aimed a blow which caught me across the top of the hat I was wearing and smashed it. I drew my revolver and struck him across the head with it – Nutkins presented a loaded revolver that seemed to have no effect and as a last resort I struck him with an unloaded revolver, I think two or three times across his forehead, he fell down eventually and we got the handcuffs on him. A search was made for revolvers and one was found loaded with six cartridges. We then took him from the house on a stretcher to hospital where the wound to his head was attended to.

Bath police inspectors Newport and Noble were involved in the arrest – Newport aided Marshall in subduing Fowler while Noble detained Milsome without much of a struggle, but neither were mentioned in the Old Bailey transcript.

After treatment, Fowler was taken to Bath police station where he joined Milsome and they were jointly charged with murder and burglary before being taken to Holloway Prison in London.

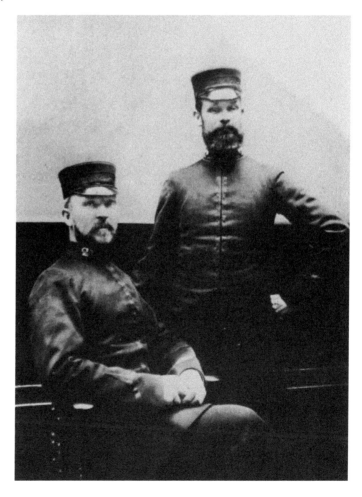

Inspector Newport and Chief Inspector Noble.

Fowler denied everything outright, saying that he was at a lodging house in Kensal Town and had nothing to do with Milsome. His partner in crime tried a different approach. He wrote to Marshall making a full confession and outlining the crime in full, except to say that it was Fowler who committed the murder while he (Milsome) was out of the room. The pair had intended to go abroad, but for some reason they joined a travelling circus that led them to Bath. When told that his co-defendant had confessed he made a statement of his own:

> My pal, the dirty dog has turned Queen's Evidence, and our mouthpiece [solicitor] is no use; but I can tell a tale as well as he. There was £112 in the safe and I gave him £53 and some shillings, a half share minus my expenses. Is it likely that I should give that to a man who stood outside? He put his foot on the old man's neck until he made sure he was dead.

The job was put up by a third party, who Fowler refused to name, and they had expected to find £3,000 to £4,000 in the safe. They were clever enough not to take the jewellery or items which could be traced, but not clever enough to have arranged for such items to go straight to a fence who would have broken them down and sold them on immediately. Nor did they have the sense to lie low and carry on their normal lives but started spending the cash, immediately attracting attention.

Above left: Albert Milsome, thirty-three.

Above right: Henry Fowler, thirty-one.

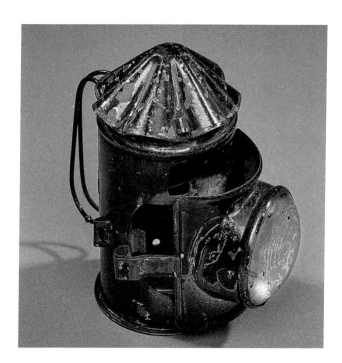

The lantern used in the
robbery and murder.

The trial was held at the Old Bailey before Mr Justice Hawkins on 19 May
and, under the legal principle of 'common purpose', if they had both gone there
to rob Smith then both were responsible for his death and thus equally guilty. The
evidence had suggested that the two burglars had jointly committed the tying up
and killing of Smith. The trial was shortened because of Milsome's confession
and Fowler was still furious at the betrayal by his former friend. While the jury
were out considering their verdict, Fowler jumped up in the dock and started
throttling Milsome. A number of policemen then became involved in a furious
struggle and eventually pulled Fowler off him. The jury found them both guilty
very quickly and they were sentenced to death.

Milsome collapsed when he heard the guilty verdict but Fowler just laughed
at the failure of Milsome's confession, and mimicked his partner's protesting
of the verdict. When asked if they had anything further to say, Fowler told the
court that there had been two miscarriages of justice and named the convictions
of two burglars in Lewisham for whose crimes Fowler now wished to claim
responsibility. He asked the court to review those two sentences, but Fowler was
lying; the evidence against the two burglars was stronger than Fowler thought,
and they were friends of his for whom he was trying to do a favour. An unpleasant
man, but professional to the last.

The governor of Newgate, Colonel Millman, was afraid that Fowler might
attack Milsome again on the scaffold and it was decided to hang the two men
with a third party between them. Luckily, a recent double murder had been
committed in Whitechapel by a burglar named William Seaman. He was put

between Milsome and Fowler on the gallows at Newgate Prison on 9 June 1896 but, despite fears by the executioner Billington, Fowler did not make a scene. He came out onto the scaffold after Milsome and Seaman were set up, and when he was brought into the shed he asked 'Is Milsome there?' and having been assured that he was, said 'very well, you can go on'.

Seaman, until then unaware of why he was being placed as he was between the Muswell Hill murderers, said, 'Well this is the first time in my life I've ever been a bloody peacemaker.' Shortly afterwards the bolt was drawn and the three descended to their deaths.

For lovers of statistics, Milsome weighed 9 stone and was given a drop of 7 feet 6 inches, a longer drop given 'on account of the prisoner being small and slight'. Fowler was a heavier man at just over 12 stone, and was given a drop of 7 feet as his 'neck was very strong and muscular'. In both cases there was fracture/dislocation of the cervical vertebrae. A nice clean job.

15

THE HEAD IN THE OVEN: REGINALD HINKS (1933)

A very pleasant Victorian villa, 43 Milton Avenue, lies in the suburbs of Bath, one of many in an area known as Poet's Corner as the area has many streets named after historical authors. In 1933, Mrs Constance Anne Jeffries, a divorcee, with her five-year-old daughter, Beryl, was living there with her father, James, an eighty-one-year-old retired master tailor from Dorking, where he still had a shop and owned some cottages. James was suffering from dementia and was often confused. His wife had died in January 1933 and Constance was now caring for him with the help of two nurses.

43 Milton Avenue.

One fateful day she opened the door to vacuum cleaner salesman, Reginald Ivor Hinks. Although described as tall, slim, handsome with sharp animated features and black silky hair, he was also arrogant and conceited, boastful and hot-tempered. Hinks had been born in Teddington, Middlesex, in 1901 and moved to Bath at the age of seventeen to take up an apprenticeship with engineering company Stothert and Pitt. His time with the company did not last long – his work was poor and his workmates suspected him of stealing their tools. He left in 1921 before he could be sacked and joined the Royal Corps of Signals, but was dismissed for being 'slack, lazy and untidy'.

After the army he moved to London where he met a widow with whom he lived for some years, taking on bar work and working his way through her small legacy of £200. They entered service as butler and cook, where he was suspected of a number of petty thefts from guests. The pair fell out and, after giving her a severe beating, he moved on to a young woman in Kensington and obtained a job in Sutton as a waiter. He moved back to Bath in 1932 and one of the first things he did was snatch a woman's handbag. The full extent of his petty criminality will probably never be known.

Very shortly after meeting Mrs Jeffries the couple married in March 1933 and Hinks moved into Milton Avenue. Constance was quite well off having £2,000 in the bank, and her father owned various properties. Hinks left his dead-end

Reginald Ivor Hinks.

Constance Ann Jeffries.

job and one of the first things he did was to convince Mr Pullen to sell the shop in Dorking for around £900 and hand the money over to him. He bought a car and moved the family to a smaller house called *Wallasey* in Englishcombe Lane. He then dismissed his father-in-law's nurses and put the old man on a restricted diet.

The family solicitor, a Dr Carpenter, was becoming alarmed at the way in which the new husband seemed to be taking over the estate and arranged an 'order in lunacy' to safeguard Mr Pullen's affairs. In her father's will, she would eventually receive all the property but until then the solicitor advised the couple to let out the house in Milton Avenue at five guineas a week. This was to be their only income; until her father died, there would be no more access to his money or property. Although the eighty-one-year-old was frail in mind, he was physically very fit and Hinks perhaps decided that his demise would have to be hastened.

Hinks underestimated his father-in-law's fitness and sent him out for long walks alone in the city centre, hoping that he would get run over or have an accident, but this tactic was rumbled by a local policeman who saw James Pullen apparently sleepwalking while being followed by Hinks in his car. The old man collapsed, was bundled into Hinks' car and taken home.

On 30 November at 7.30 p.m. in the evening, Hinks called the police, a doctor and the fire brigade to his home, saying that Mr Pullen had been found

unconscious in the bath and had been discovered with his head beneath the water. Presumably to everyone's surprise, Pullen was sitting up in the bath, wrapped in a blanket and clutching a hot water bottle. The doctor remarked that the old man was in very good health, and that the exercise regime and restricted diet had 'toughened him up'. Hinks' attempts at doing away with the old chap were becoming worthy of Monty Python and the final sketch was perhaps the silliest of them all.

Less than twenty-four hours later on 1 December, while Mrs Hinks had gone to the cinema, the emergency services were called once more. This time Pullen was found lying on the kitchen floor with his head in the gas oven. Two coats had been draped over the oven door, shelves had been removed and Hinks said that he had found two gas taps turned on and had acted quickly. 'You might find a bump on the back of his head. I pulled him out of the gas stove and his head fell with a bump on the floor,' he said. Pullen was alive, but died shortly afterwards.

As with any unnatural death an inquest was held before a jury in early December. Initially the affair attracted little attention, but the police and the doctor both queried the alleged suicide. They could not believe that a man with his level of dementia could have taken all the necessary steps required to have killed himself in this fashion. Mr Pullen's doctor, Scott Reid, believed that the bruise on the man's head had been caused by a blow before any gas was administered to try and stun the victim.

Englishcombe Lane.

Mrs Hinks gave evidence to say how difficult and violent her father had been, often striking not only herself but her mother; he had a violent temper, he threw things and was often threatening suicide. When his ability to turn on the gas taps was questioned she claimed that he often made himself cups of tea. She often broke down in tears when giving her evidence and claimed that Mr Hinks had been kindness itself towards her father and, surprisingly, this was supported in evidence by the two nurses who had been dismissed and who also reported his conversations about suicide. Notwithstanding her obvious bias towards the suicide theory, an autopsy proved that the bruise had been inflicted before Pullen's head had entered the gas stove.

The coroner's jury agreed with the suspicions of the experts and on 11 March found that 'death [was caused] from gas poisoning accelerated by a severe blow on the head administered by Hinks shortly before death'.

Upon his arrest he said 'I have nothing to say and nothing to fear-nothing at all-except that it's all absurd', and on 6 March Reginald Ivor Hinks, aged thirty-two, found himself ascending the steps at the Central Criminal Court charged with murder in front of Mr Justice Branston. The trial took only five days, with most of the evidence having been examined at the coroner's inquest, and on 10 March after the jury had been out for one hour and thirty-five minutes the judge, without any comment, donned his black cap and passed a sentence of death. When asked if he had anything to say Hinks replied, 'I loved my home, my wife and baby and Mr Pullen too much to do him any injury. The verdict is not correct.' Upon hearing the news his wife wept bitterly and said, 'It is terrible. I thought the verdict would be different. I still believe my husband is innocent.' After the sentence Constance Hinks stayed at a hotel in Bristol and went to visit him every day, having stayed with a cousin in London during the proceedings at the Old Bailey.

An appeal that had looked very hopeful for a while was dismissed and Mrs Hinks continued to visit her husband in Horfield jail. She was seen to visit her solicitor, with a view to drawing up a petition to the Home Secretary against the execution of her husband. She delivered this petition herself, driving up in a plum-coloured motor car with Fifi, a pet monkey that her husband had given her the previous Christmas. The petition was declined and on 3 May 1934 Hicks was hanged at Horfield Prison in Bristol, still maintaining his innocence with his six-year-old stepdaughter believing that he was ill in hospital.

* * *

The speed of their marriage raises the question of whether they had known each other for a while before. She had managed to divorce her husband Alfred in 1930, no mean feat at that time for a woman with a two-year-old daughter, and it would be fascinating to know what the issues were. She supported her husband unconditionally throughout his trial and paid for his defence with her

own money, estimated to be in the region of £1,500. Her love and support for him seemed sincere and genuine.

Were Hinks' almost comic attempts at murder real? Did he really follow him down the road in the car waiting for him to have an accident? Why, after an attempted drowning did the victim remain in the bath with a blanket and hot water bottle and why all the unbelievable theatrics around the gas stove? Surely there are much easier ways to kill a senile old man. On balance he probably did it, and the conviction was justified; whether Constance was involved we will never know, but there was surely enough confusion in the case to warrant a sentence of life imprisonment rather than death.

Wallasey was sold and Constance announced afterwards that she was 'going miles away hoping that beautiful surroundings and new friends will help me forget'. She intended to visit Devon and possibly go abroad but had no intention of changing her name, nor was she ashamed to be known as Mrs Hinks. Her father's inheritance came to £1,957.

In a bizarre twist, less than a year later in January 1935 while living in Horley, Surrey, Constance, now aged forty-two, gave birth and named the father as Reginald Stanley Bates of Camberwell, the author of some of the many letters of sympathy that she had received before and after the execution of her husband. She was very touched by his letters and they agreed to meet where she was staying in Brighton towards the middle of May. They began an affair immediately and according to her evidence he agreed to marry her within days but fell in love with somebody else and the couple parted in September. Constance lost the paternity case and some other petty matters she had brought against him. After this she moved to Hailsham in Sussex where she died in 1972 at the age of seventy-nine, still using the name of Hinks.

MAD AND BAD? JOHN STRAFFEN (1951)

One of the saddest cases to come before the criminal courts must be that of John Thomas Straffen.

Straffen was born in Borden, Hampshire, on 27 February 1930 but spent his early years in India where his father was in the armed forces. His older sister was described as a 'high-grade mental defective' and died in 1952, by which time the family were crammed into a small top-floor flat in a beautiful Georgian house at 2 Fountain Buildings, Walcot. They had moved to Bath in 1938 after his father was discharged and John was in almost constant trouble with the police for petty offences, eventually being sent to a special school for children with additional needs. On 27 July 1947 a thirteen-year-old girl reported to the police that a boy called John had put his hand over her mouth and asked, 'What would you do if I killed you? I've done it before.' He was now seventeen years old and when questioned by the police admitted to a number of low-level burglaries and breaking and entering but the girl's complaint wasn't proceeded with.

Some weeks later he was quite happy to confess to having strangled five chickens belonging to the father of a girl that he had fallen out with. He was remanded to Horfield prison with the medical officer diagnosing him as 'feeble minded' and on 10 October 1947, he was committed to the Hortham Colony in Almondsbury, Bristol. This was an open facility, which specialised in training offenders with learning difficulties for resettlement into the community. As he was in for burglaries his certificate stated that 'he was not of dangerous or violent propensities'. He was well behaved in the main and kept to himself and so was sent to a low-risk agricultural hostel in Winchester. Here he stole a bag of walnuts and was sent back to Hortham in February 1950. The following year he walked out and went home without leave and became violent when the police went to recapture him.

Straffen was eventually released on licence in 1951 and examined at a Bristol hospital where it was discovered that he suffered from 'wide and severe damage to the cerebral cortex, probably from an attack of encephalitis in India before the age of six'. His behaviour continued to be good and he even got a job in a market garden but was still under the care of the hospital and assessed as having a mental age of ten.

On 15 July 1951 Straffen was on his way to the cinema and passed 1 Camden Crescent, where six-year-old Brenda Goddard lived with her family in the basement. She was picking flowers on Rough Hill at the back of her home. He engaged her in conversation and offered to show her a place with even more

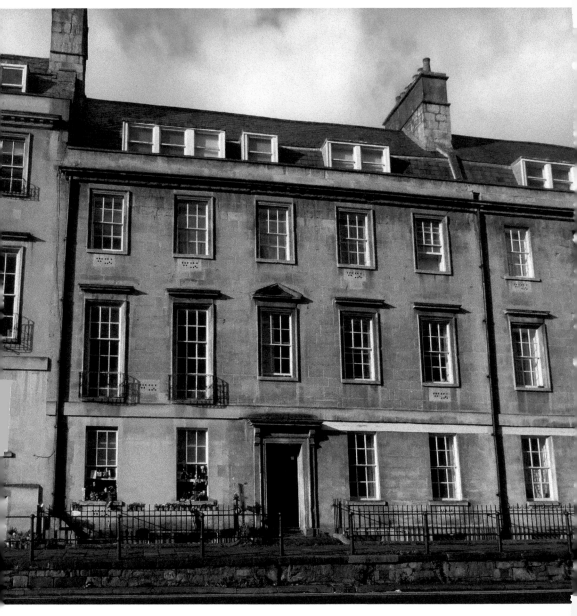

2 Fountain Buildings, Walcot.

flowers. He lifted her over a fence and into a copse and they walked into the wood together where he bashed her on the head with a stone to stun her before strangling her. Straffen made no attempt to hide her body and continued on his journey to watch the film *Shockwave*.

He was interviewed by the police on 3 August but, although he admitted to being in the woods, there was no evidence against him and so he was released.

Horfield Prison, Bristol.

Later he told them that he had done it to give the police 'something to really do' instead of pursuing him for trivial offences.

> She had her back to me when I squeezed her neck. She went limp. I did not feel sorry. I forgot about it, I went back over the wall, I had no feeling about it, I forgot about it.

Straffen had developed an intense hatred of the police, blaming them for all his troubles, real or imagined, and was apparently so impressed by the amount of press coverage that killing the young girl had achieved that he saw this as a way of causing them maximum inconvenience. It was the sensible thing to do, he claimed, as it was a lot easier than burglaries.

1 Camden Crescent.

John Straffen in April 1952.

A few days later on 8 August he went to the Forum Cinema in Bath to see *Tarzan* and got talking to nine-year-old Cicely Batstone of 1 South View, Camden Road. He persuaded her to accompany him to the Scala cinema where they saw a film about US troops. Straffen explained his actions to Superintendent Rudkin:

> She was a bright little girl and we were talking together in the downstairs seats. We saw the film through, came out together and it was light. We went for a walk. We passed through a gate into a field and walked up the slope behind the hedge. She said she was tired and laid on the grass. In the field there was a bit of a struggle. She went limp. I was holding her in the front by the neck. A few years ago, I had a breakdown. She was dead when I left her but you cannot prove it. There was another couple in the field.

To another officer he is alleged to have said:

> I sat behind her. It only took a couple of minutes and she was dead. She was taken by surprise. I could have got[ten] away with the first one too. They did not have any witnesses.

Her body was found in a field known as The Tumps, off Broomfield Road. Many witnesses had seen the pair together and a bus conductor recognised him as a former workmate.

Straffen was charged and committed for trial at the Somerset Assizes, Taunton, where on 17 October he was judged insane and unfit to plead. The court remarked that 'you might as well try a babe in arms, if a man cannot understand what is going on he cannot be tried'. He was ordered to be detained, 'until His Majesty's pleasure be known'.

On the afternoon of 29 April 1952, Straffen climbed onto a shed roof and over a 10-foot wall, jumping down the other side of the perimeter barrier at Broadmoor Hospital. The escape was well planned. He wore his suit under his overalls and hid them in a wood around 3 miles from the hospital, which gave his pursuers an idea of his route. He was free for around four hours before being recaptured around 7 miles from the prison in Arborfield at 6.40 p.m. Details of his recapture are uncertain. Some say that he was recognised and challenged by a police officer and at the time was accompanied by a seven-year-old girl who was unharmed and whom the police refused to name. Some reports claim that he gave up without a struggle, others that he ran straight into a tree while being pursued and that he put up a great fight resisting arrest brandishing a tree branch. Whichever account is correct, he was seen to have two black eyes and a badly bruised face on his way to Crowthorne police station.

That same day five-year-old Linda Bowyer of Farley Hill was reported missing; she had left home to try out her new bicycle and had not returned. She was found strangled in a bluebell wood after an all-night search around a quarter of a mile from her home. Death had been caused by manual strangulation. Straffen was repeatedly interviewed at the station but would only keep repeating 'I know nothing' and 'This is a frame up.' There was no sexual motive to any of his murders.

The chances against an imprisoned double child murderer finding another victim and potential victim within four hours after an escape must be quite phenomenal. When captured his only request was that the police collect his Teddy bear, 'Rupert', and his Beano Annual from Fountains Buildings, which they did. He seemed totally unconcerned about his predicament.

At his trial in Winchester, the prosecution argued that he was fit to stand trial and the judge, Mr Justice Cassels, agreed. The first trial was aborted due to one of the jurors letting it be known that he believed one of the prosecution witnesses to be guilty. At his second trial on 24 July, he was found guilty after the jury had been out for half an hour and sentenced to be hanged on 4 September. There was an appeal on points of law but these failed and he was eventually reprieved by the Home Secretary, David Maxwell Fyfe, on 29 August on the grounds of insanity. He was sent initially to Wandsworth prison and in 1956 moved to Horfield in Bristol after evidence that he was involved with others in an escape attempt. He was apparently the first prisoner to occupy a new high-security wing at Parkhurst, which opened in 1966. He spent his sentence in prison because there was claimed to be no mental institution secure enough to guarantee his confinement. He was described as arrogant and hostile, always on his own and

South View, Camden Road.

never speaking unless to ask for something. Straffen died at Franklin prison, County Durham, on 19 November 2007 at the age of seventy-seven after being in prison for fifty-five years, a record to be surpassed only by Ian Brady.

Mad or Bad? Neither term has as much validity today, if it ever had. The original guidance to such a question dates from the 1840s and is known as the McNaughton Rule after Daniel McNaughton who, suffering from delusions, shot and killed Edward Drummond believing him to be Sir Robert Peel. He escaped the death penalty as he was judged to be insane and sent to a mental institution. The basic rule states that,

> Every man is to be presumed to be sane, and [...] that to establish a defence on the grounds of insanity, it must be clearly proved that, at the time of the committing of the act, the party accused was labouring under such a defect of reason, from disease of the mind, as not to know the nature and quality of the act he was doing; or if he did know it, that he did not know he was doing what was wrong.